SUSSEX'S
MILITARY HERITAGE

Dean Hollands

AMBERLEY

This book is dedicated to the memory of all those whose actions and deeds have created Sussex's military heritage and to those who tirelessly strive to preserve it.

First published 2020

Amberley Publishing
The Hill, Stroud
Gloucestershire, GL5 4EP

www.amberley-books.com

Copyright © Dean Hollands, 2020

Logo source material courtesy of Gerry van Tonder

The right of Dean Hollands to be identified as the Author of this work has been asserted in accordance with the Copyrights, Designs and Patents Act 1988.

ISBN 978 1 4456 9517 4 (print)
ISBN 978 1 4456 9518 1 (ebook)

British Library Cataloguing in Publication Data.
A catalogue record for this book is available from the British Library.

Typesetting by Aura Technology and Software Services, India. Printed in Great Britain.

Contents

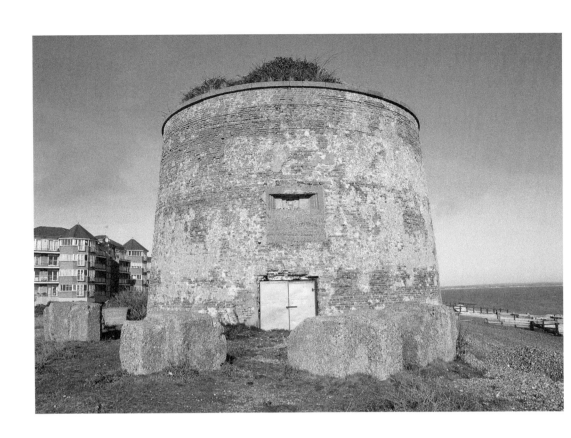

Introduction

Sussex's formation as an ancient kingdom and then its rebirth as the counties of East and West Sussex has been a brutal and bloody affair. Unrelenting waves of invaders, raiders and conquerors seeking fertile lands, valuable resources and opportunities to create new communities have destroyed, displaced and integrated the local populace, their traditions and cultures into their own.

From Bronze and Iron Age Celts, through to the Romans, Saxons and Vikings, remnants of their military achievements and influences remain visible today. While such accomplishments were often violent encounters, others were less so.

The Norman conquest of 1066 ended that cycle of invasion and occupation, yet the fear remained, and raiders and invaders continued to bring death and destruction to the shores and inlands of Sussex.

Responding to these threats and advancements in warfare, new fortifications and methods of defence were deployed along the coastline and further inland. Norman castles that once dominated the skyline gave way to Tudor forts who in turn were replaced by Georgian and Victorian fortifications. During the twentieth century, the new RAF and civil defence organisations defended the air space above Sussex, protecting those below from attack. The Cold War threat saw secret nuclear bunkers being built to house regional war rooms, emergency control centres, and observation and monitoring posts.

In addition, Sussex's militias and military formations have steadfastly defended the county's and the nation's interests in conflicts at home and abroad. Sussex's role in the English Civil War was not insignificant and while the great battles may have been fought elsewhere, the county's contribution would ultimately prove influential.

Sussex's military links to the Crimean and Boer Wars are commemorated, as are the deeds of its soldiers during both world wars. Allies from many nations lost their lives bravely defending the county's skies and coastline during the Second World War. Others lost their lives in tragic circumstances, unwitting victims and unsung heroes who are remembered on monuments and memorials across the county.

From Stone Age to Cold War, the county's landscapes, castles, fortifications, military museums and attractions are the legacy of Sussex's military heritage, and these remain, waiting to be explored and experienced. The extent of that legacy makes it impossible to comment upon every person, place or event who has featured in its making. Rather, this publication summarises the pivotal events that have shaped the county's military history along with some lesser-known people and occurrences whose heritage can still be seen and experienced today. In so doing, the author hopes the contents and images will inspire and stimulate others to examine and explore further the county's wonderful military heritage.

1. Invaders, Raiders and Conquerors

The first major invasion of Sussex was by the Belgae Celts around 480 BCE. They crossed the channel at its narrowest point, sailed westward along Kent's coast, arriving at Sussex and bringing with them new knowledge, weapons, tools and bronze. The second major invasion of Sussex followed around 250 BCE by successive waves of Celts from the Marne area of France. As descendants of the iron-producing regions of Belgium and north-west Gaul, the Marnians brought knowledge of ironworking and a formidable new weapon: the horse-drawn chariot. The Belgae Celts built additional hillforts and strengthened existing ones to countermand the invaders but, undeterred, the Marnians fought on and occupied the western and central downlands, establishing Cissbury, north of modern Worthing, as their capital.

The Marnians were excellent ironworkers, capable of producing lighter, stronger and sharper weapons. Leaders armed with long ornate iron swords and throwing spears fought on horseback and from chariots, while foot soldiers used longer spears to thrust at the enemy.

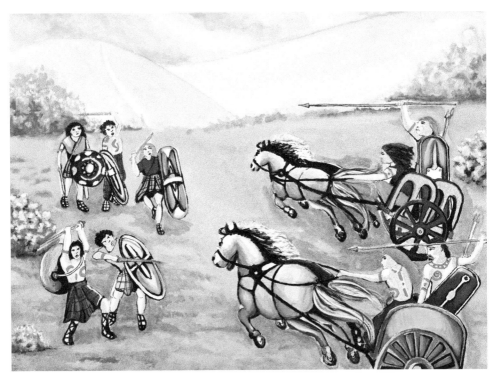

Bronze Age Celts arrive. (SD)

Both carried wooden oval body shields, some wore chainmail threaded onto cloth and others fought naked. As well as blue protective tattoos, they painted magical and pagan symbols on their bodies to intimidate the enemy.

The next significant invasion came in 75 BCE, when people from the Atrebates tribes, a mix of Celtic and Germanic peoples, began invading southern Britain. However, it would be the Romans, under the command of Titus Flavius Vespasianus in 43 BCE, who would mark Sussex's fourth major invasion. Little is known about the Roman army in Sussex. Most historians agree Chichester Harbour was where they disembarked and established their beachhead. Unlike neighbouring Kent and Hampshire, no major conflicts were fought, suggesting subjugation agreements with local chieftains had been agreed with Roman envoys in advance of their arrival.

During their invasion the Romans used Fishbourne as a supply depot and Chichester (Noviomagus Reginorum) to garrison troops. In the third century, they began building a system of 'Saxon shore forts' along Britain's coastline to protect key harbours from Saxon, Jute and Angle raiding parties. A shore fort was built at Pevensey (Anderitum) and garrisoned with 400 men of the Numerus Abulcorum, a Roman auxiliary unit from Spain. Roman naval ships, used to locate and intercept Saxon pirate ships, were berthed at the fort, dying their sails and rigging green to avoid detection.

Romans ambushed by Celts. (SD)

Between 388 and 410 CE, the western empire of Rome experienced political unrest, military power struggles and attacks from barbarian tribes intent on sacking Rome. In 407 CE, General Constantine III rose to power in Britain during a bloody power struggle in which he was proclaimed emperor by the local legions. Seeking to take advantage of the turmoil and overthrow the emperor of Rome, Honorius, he removed the army from Britain to Gaul.

With Britain unprotected, the way was left open for Saxon invaders and between 473 and 491 the army of King Aelle, led by his sons Cymen, Wlencing, and Cissa, invaded Sussex three times. In 477 CE, they arrived at a place they called Cymenshore traditionally thought to be in the Selsey area. Slaying the local defenders, they drove the rest into the forest of Andred. Eight years later at the Battle of Mercredesburne, believed to be modern-day Ashburnham and Penhurst, they fought again. Having gathered reinforcements in 491, they lay siege to Pevensey and when it fell, they massacred the survivors and razed the city by fire as they conquered Sussex. Little is known about Aelle, but according to the Anglo-Saxon Chronicle, his influence was felt far beyond his lands in Sussex and he died fighting King Arthur's army in the West Country. Cissa reigned as the King of the South Saxons in Sussex for seventy-six years, giving his name Cissa's Castre (Cissa's Camp) to Chichester.

In 607 CE, the Saxon King of Wessex, Ceolwulf, defeated the South Saxons, absorbing Sussex into the Kingdom of Wessex. The following century, Sussex regained and lost autonomy several times but was under the dominion of Wessex when the Kingdom of England was established in 924 CE.

The first recorded account of Danish pirates raiding Sussex was an unsuccessful attack on Chichester in 894. Having killed several hundred attackers, the local defenders pursued the fleeing force back to the shoreline where they captured three of their ships. On the way the defenders secured another victory at Kingley Vale, north of Chichester, where a great yew forest was planted to commemorate their success. In 896 two Danish ships from a passing raiding party ran aground. The Danes were captured, taken to Winchester and hanged.

Despite setbacks, by 927 King Alfred had driven the Danes out of Wessex and halted the Viking expansion westward. Following a period of stability, the Danes, sensing weaknesses in the English government, resumed raiding in 994. Ravaging the Sussex coast, they raped, pillaged and murdered in search of precious resources and treasures. In 1017, the last Saxon King of Wessex, Edmund Ironside, died and all resistance to the Danes died with him. The Danish leader, Cnut, was made King of England and the Danish invasion was complete.

The most famous invasion of Britain occurred in Sussex on 14 October 1066 when William Duke of Normandy, having earlier landed his forces at Pevensey, fought King Harold's army at Senlac Hill. Although similar in size and evenly matched, Harold had the strategic advantage of being sited on the top of the hill. Unable to break Harold's shield wall, the Normans tricked the English into believing that William had fallen and staged a mock retreat. Harold broke his defensive line and pursued the fleeing Normans, during which his forces were ambushed by Norman cavalry.

Re-enactment of the Battle of Hastings, Senlac Hill.

In the bloodbath that followed, Harold and his brothers Leofwine and Gyrth were killed and Harold's dead body was hacked to pieces by Norman knights. Shocked at the level of slaughter, the Pope, who sanctioned the invasion, ordered William to build a monastery as an atonement for the bloodshed. In response, William built Battle Abbey near to the site of the clash. Today a plaque on the abbey wall commemorates the battle.

While the Norman invasion proved to be the last time England would be conquered, it would not be the last time that foreign forces would land on English soil or that an invasion was attempted. During the 1300s, French raiders destroyed crops and killed many people along the south coast. In Sussex where the English Channel is at its narrowest, Winchelsea and Rye were often the first places to be attacked.

Rye and Winchelsea were particularly vulnerable to French raiders at the start of the Hundred Years' War with France (1337–1453), following earlier attacks on the towns in 1339, in which hundreds of houses were burnt. In 1359, a force of 3,000 French men landed at Winchelsea and entered the Church of St Giles, where townspeople had sought refuge. There, the young women were raped, tortured and murdered along with another forty people who they butchered, with no mercy shown. Four hundred residents also died in the harbour during fighting as the French escaped, taking with them thirteen laden ships. Today the church no longer exists but those slaughtered were buried there and the lane leading to it became known as Deadman's Lane.

A year later, Rye and Winchelsea suffered further French raids, during which their ports and lands were ravaged and burnt. The largest raid came in 1377 when 4,000 Frenchmen

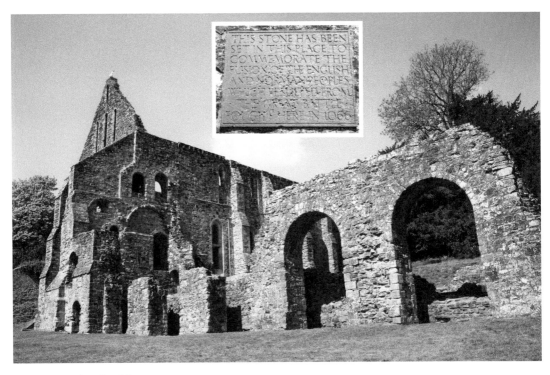

Ruins of Battle Abbey.

Insert: Plaque at Battle Abbey.

in 120 ships led by Admiral Jean de Vienne once more looted and burnt the town of Rye, stealing the bells of St Mary's Church. Rye Castle proved incapable of defending against such attacks and as a result, a stone wall enclosure and two strong defensive gates were built around the town.

The French next attacked Winchelsea but were rebuffed by the town's new defences: walls made of wood, stone and earth with a large ditch on its eastern side. Undeterred, they continued along the coast, ransacking Hastings, destroying and looting its churches. Continuing westwards, Admiral de Vienne made landfall near Rottingdean, where his troops were ambushed by local archers who despite being outnumbered, delayed the French long enough for villagers to escape before they withdrew. In Rottingdean, the French looted and burnt the church of St Margaret and set fire to surrounding houses. Today at the west end of the nave, three pillars show scorch marks made by the fire.

Moving towards Lewes, Admiral de Vienne's scouts reported 500 locals heading towards them. The force was led by John de Caroloco, Prior of St Pancras Church, Lewes, who was unaware that the French were ashore in such numbers. Having hidden the bulk of his force in the woods on Beacon Hill, Admiral de Vienne left a small detachment at the village as bait. On seeing the smaller French force, Prior de Caroloco launched his attack. The French, feigning retreat, headed towards the beach. Admiral de Vienne unleashed his main force into the rear of Prior de Caroloco's men, capturing him and killing 100 others.

Above: St Margaret's Church, Rottingdean.

Right: The Watchbell Road bell.

With the local force beaten, the French plundered their way to Lewes, besieging the town for five days before returning to France. The following year, militia from Rye and Winchelsea attacked the French coast where they recovered the bells of St Mary and captured many wealthy persons whom they ransomed. One of the recovered bells was hung in Watchbell Street, Rye, to warn of subsequent French attacks on the town; today a newer bell marks the location.

Admiral Jean de Vienne led further raids against Sussex in 1380 where, once more, the main targets were Winchelsea and Hastings. The final French raid of the Hundred Years' War was against Rye in 1449. Sporadic French raiding continued along the Sussex coast for the next 200 years, most notable at Brighton in 1514, Shoreham in 1545 and Seaford in 1548. The threat and attempts of French invasion rose and fell but never went away until late 1800.

When England and Holland became commercial and maritime rivals for control of the trade routes in the New World, the Dutch became the next threat to Britain's security. When war broke out in 1652, Admiral Blake sailed from Rye harbour with sixty ships to disrupt Dutch fishing in the North Sea and their trade in the Baltic. In response, the Dutch fleet under Admiral Tromp attacked the south coast at Hastings, plundering houses, stealing cattle and capturing a large merchant ship. It was during this period that the first and largest warship ever built at Shoreham was launched. The Dover was a man-of-war carrying forty-eight guns and was so large that the crew had difficulty getting it out of the port.

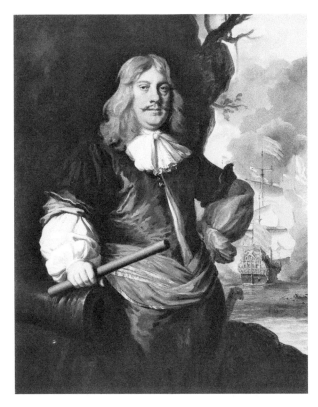

Lieutenant-Admiral General Cornelis Tromp.

The next threat faced by Sussex came in the wake of the First World War; the aggressor was Germany. With trench warfare established, the threat of invasion subsided. Sussex, however, was close enough to France to be vulnerable to new forms of warfare: air raids and U-boat attacks.

To counter such threats, the Royal Flying Corps (RFC) and the Royal Naval Air Service (RNAS) built aerodromes and seaplane and airship stations along the coast. At Seaford Bay a station was built that allowed seaplanes to be launched from the beach. Built to protect Newhaven, a major supply port for the Western Front, the station comprised three railway carriages and two large hangars and was equipped with six Short Type 184 seaplanes responsible for performing anti-submarine patrols over the English Channel.

While seaplanes at Newhaven defended the port and protected the ships crossing the channel, aviation history was being made at Polegate by the RNAS. In addition to flying airships, they were flying new 'Submarine Scouts'. Initially designed to provide aerial reconnaissance, the innovative design comprised an aircraft fuselage, minus its wings, hung below a gas balloon. Eventually fitted with small bombs, their role became not only reconnaissance but also attack. The demand was so great for these Scout ships that various versions were constructed and fitted with machine guns. The last class to be designed was the SS Twins, which could carry a crew of five, had a top speed of 57 mph and could stay airborne for up to two days. To improve the operational abilities of these craft, two mooring-out posts acted as satellite sites for the main station, one at Upton in Dorset and the second at Slindon.

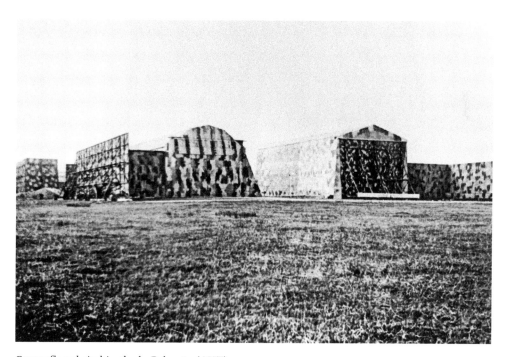

Camouflaged airship sheds, Polegate. (AHT)

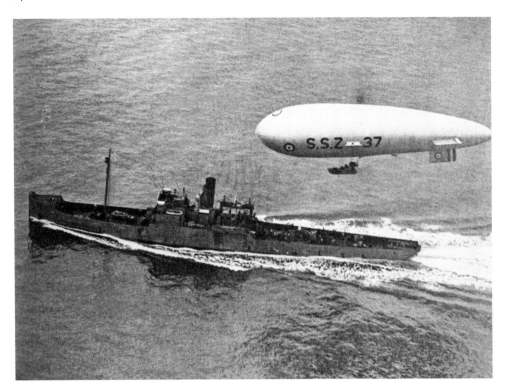

Submarine Scout Class Airship SSZ 37. (AHT)

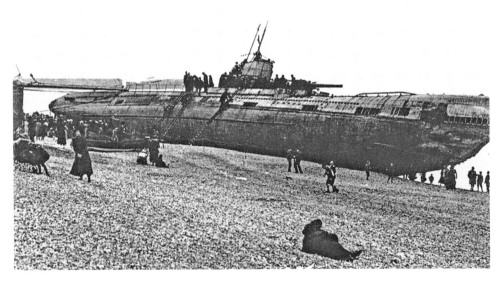

German submarine U-118.

One of the more interesting airships based at Polegate was the 'all black' S.S.40. Assembled amid tight security within a guarded shed, the ship was intended to transport agents under the cover of darkness to enemy territory; however, the war finished before it could complete its secret role. On 1 November 1916, 78 Squadron RFC was formed at Harrietsham, Kent, to counter the threat of German airships and bomber raids upon London. Tasked with protecting the southern English coast, one flight of this squadron was based at Telscombe Cliffs, Lewes.

Throughout the war, the county of Sussex became a training ground for preparing troops and aviators for deployment to the front line. While the county of Sussex remained virtually untouched by enemy action, it wouldn't be so lucky when the dark clouds of war returned in 1939. Invasion fears became a reality when, having refused to accept Germany's terms of peace, reconnaissance over Boulogne and Calais in August 1940 revealed a large build-up of barges and small craft in the harbours and surrounding areas.

Hitler's invasion plan, 'Operation Sea Lion', first required air and naval supremacy over Britain and the Channel. This would enable the German Navy to convey the main invasion force to Britain's shores, landing it along a 200-mile front, with Camber Sands, Winchelsea, Bexhill and Cuckmere Haven identified as landing points.

During the summer of 1940, Reichsmarschall Hermann Goring began the Luftwaffe's all-out campaign to destroy the RAF. In July, German bombers attacked shipping to clear the Straits of Dover and in early August, air attacks against British convoys and ports began. By mid-August, the German main offensive, *Adlerangriff* (Eagle Attack), had begun. Its aim was to wear down Britain's air defence by targeting airbases, aircraft factories and radar stations in south-east England.

Despite being outnumbered, the RAF had superior planes. Between 12 August and 15 September 1940, the RAF pilots and ground staff stationed in Sussex played a pivotal role in what became known as the Battle of Britain. Wave after wave of German fighters and bombers relentlessly attacked the south of England, leaving the countryside littered with the bodies of airmen and aircraft wreckage from both sides. But Britain triumphed and the victory proved to be one of Britain's most important of the war.

Sussex towns and villages suffered heavy casualties from night-time bombing raids. Between 1940 and 1944, hundreds of civilians were killed, thousands were hospitalised, and hundreds of homes were destroyed. Daylight raids were no less devastating as low-flying German aircraft indiscriminately dropped bombs and machine-gunned people in the streets.

Eastbourne was the most bombed town on the south coast, receiving ninety-eight raids that dropped over 4,000 bombs and incendiary devices, resulting in 10,00 buildings damaged and 475 homes destroyed. Civilian casualties were estimated at 1,100, of which 178 were fatal. Many attacks caused incredible tragedy. In Hastings on 30 September 1940, a high-explosive bomb struck the frontage of the Plaza Cinema, wounding twenty-five people and killing fourteen others. One of those killed was Corporal Norman Kemp, who arrived in Hastings that day to arrange the funeral of his younger brother Nelson, killed four days earlier during an air raid.

On the morning of Tuesday 29 September 1942, a lone Junkers 88 German bomber targeted troops in the grounds of Petworth House. Having missed their intended target,

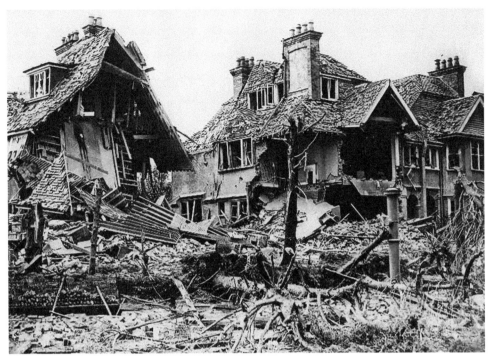

Air-raid damage, Summer Down Road, 1943. (LDC&EBC)

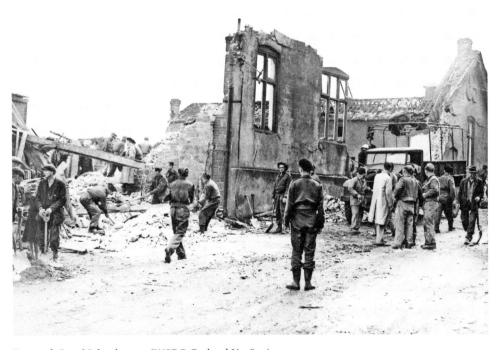

Petworth Boys' School, 1942. (WSRO Garland N21852)

the bombs fell onto a nearby boys' school killing twenty-eight children and injuring dozens more. The explosions also claimed the lives of the headmaster, an assistant teacher and a laundry worker.

Sussex's most devastating air attack took place in East Grinstead on 9 July 1943, when a single German aircraft dropped eight bombs on the town killing 108 people and injuring 235 more. During the attack, the Whitehall Cinema received a direct hit killing eighty, thirteen of whom were children. The final raids on Sussex came from Hitler's new long-range reprisal weapons: the V-1 flying bomb 'Doodlebug' and the V-2 Rocket. Once more, Sussex was on the front line, with RAF gunners and balloon handlers fighting hard to limit the damage caused on the ground.

Around 900 flying bombs fell on Sussex between 13 June and 31 August 1944, mostly in the east, along a corridor nicknamed 'Bomb Alley'. The first V-1 to fall in Sussex crashed at Mizbrooks Farm near Cuckfield in the early hours of 13 June 1944. Two other V-1 strikes of note occurred on the evenings of 5 and 12 July 1944. On the first strike, the bomb landed on a mess tent on an encampment on Crowborough Beacon Golf Club, killing nine soldiers of the Canadian 1st Battalion Lincoln and Welland Regiment, whose departure for France had been delayed. The second strike hit London Road, East Grinstead, killing three civilians and injuring thirty-eight.

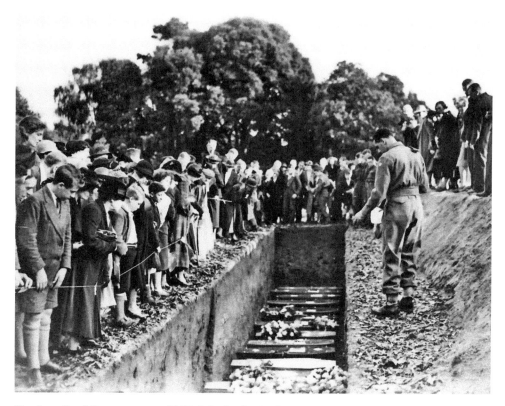

Horsham Road Cemetery, 1942. (WSRO Garland 21859)

Horsham Road Cemetery, 2019.

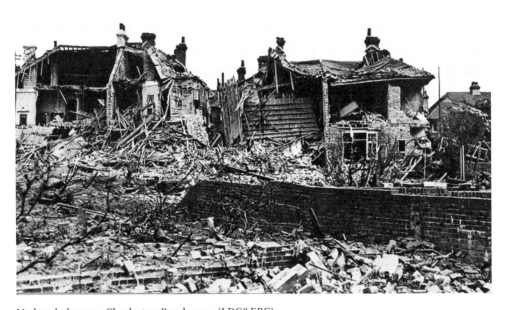

V-1 bomb damage, Charleston Road, 1944. (LDC&EBC)

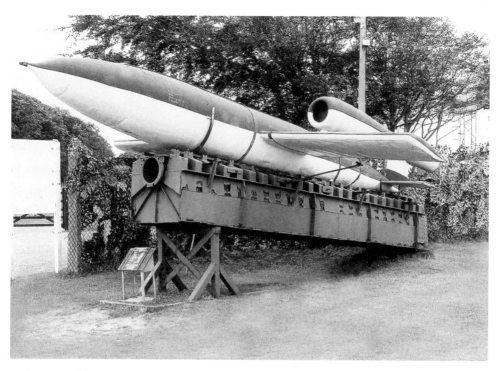

V-1 'Buzz Bomb'.

While the V-1 emitted a distinctive throbbing noise as it approached its target, the V-2 was a far more terrifying weapon; it arrived with no warning and devastating consequences. In this regard, Sussex was lucky with only three V-2 rockets strikes. The first was at Rotherfield on 14 September 1944, when a rocket disintegrated at high altitude before falling into a field. Nine houses sustained blast damage, while two police officers suffered burns handling parts of the rocket that were coated in hydrogen peroxide. The only fatalities were eight rabbits. The second struck on 16 September, landing in a field at Willingdon and injuring six persons. The third fell in woodland at Burwash causing slight damage to nearby property.

The next time a foreign army attacked Sussex was on 24 October 1984. The most ambitious and biggest operation ever carried out by the Irish Republican Army (IRA) against the British, it was the first attempt to wipe out the government since the Gunpowder Plot in 1605.

Following the deaths of several IRA hunger strikers in the early 1980s, Prime Minister Margaret Thatcher had become Ireland's most hated enemy since Oliver Cromwell. As more hunger strikers died, the IRA held her responsible and sought revenge. The IRA detonated a bomb in the Grand Brighton Hotel during the Conservative Party conference, killing five party members.

They attacked Sussex again on 30 July 1990, when they assassinated the Member of Parliament for Eastbourne, Ian Gow, by detonating a bomb under his car outside his

home in East Sussex. The IRA claimed that Gow was targeted because he was a 'close personal associate' of Margaret Thatcher and for his role in developing British policy on Northern Ireland.

Their last attack in Sussex occurred on 13 August 1994, when two pipe bombs filled with 2.5 lb (1.1 kg) of Semtex explosives was concealed in the panniers of two bicycles, one in Brighton, the other in Bognor Regis. The Bognor bomb detonated outside a Woolworths store causing damage to fifteen shops, though no one was injured. At Brighton, the bomb was detected and deactivated.

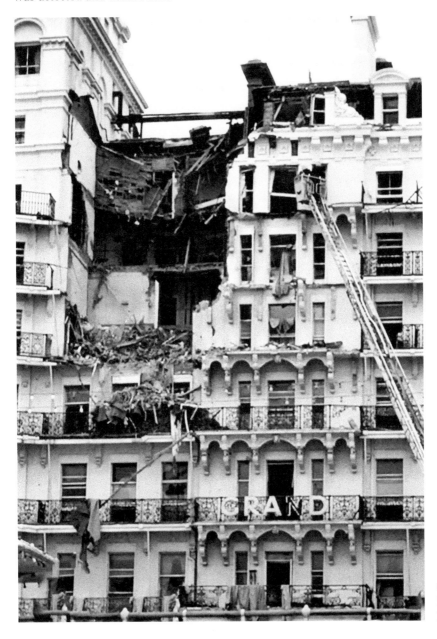

Grand Brighton Hotel, 1984.

2. Hillforts to Fortified Houses

From early times, Sussex has been a gateway into Britain from the mainland of Europe. During that time its inhabitants have defended their lands against successive raiders, invaders and aspiring conquerors. The military focus of the people of Sussex has ebbed and flowed, causing defensive sites to spring up, fall out of use and then be reoccupied when the threat of invasion seemed imminent.

Most famous for its association with the Battle of Hastings in 1066 and the Norman invasion, Sussex has been the site of other significant military incursions that shaped the county's history. While little is known about ancient battles before 1066, much can be learned from the barrows, burial mounds, standing stones, henges and earthworks that exist in the weald and downland, and along the county's coastline. These tell us much about the people who took part in those military engagements and tribal skirmishes – their way of life, their beliefs, their settlements and the fortifications they built. They tell a cyclical story of settlement, stability and peace, interspersed with periods of violence, uncertainty and fear of attack.

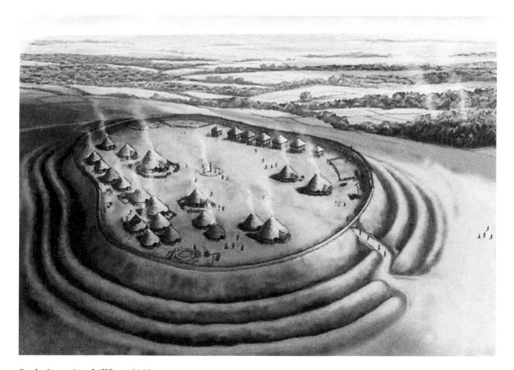

Early Iron Age hillfort. (AL)

Among Sussex's earthworks are twenty-five prehistoric hillfort enclosures. Time has taken its toll on these once impressive fortifications. Palisades that once offered protection and security have long gone, most now existing as low banks and shallow ditches in various states of disrepair. Because of their strategic locations, many sites were repeatedly attacked, occupied and redeveloped by invaders and conquerors. As a result, such sites contain evidence of settlement from pre-Bronze Age, through the Iron Age, the Roman occupation and beyond.

These Neolithic enclosures were protected by steep earthen ramparts and surrounded by one or more ditches. Entry was achieved via a walkway that bridged the ditches at either end of the enclosure and cut through the earthen ramparts, where giant gates controlled access to the enclosure.

When not functioning as forts, these enclosures were used to store crops, offer shelter from extreme weather and for social and religious gatherings. Arriving in 550 BCE, Celtic invaders used new Iron Age technologies to expand the enclosures and make the ditches deeper. They reinforced the earthen walls with timber and flint and used the excavated soil and chalk to make the ramparts higher before adding wooden palisades.

Saint Roche's Hill, north of Chichester, is known as The Trundle, derived from the Old English word 'tryndel' meaning 'circle'. At a height of 676 feet (206 metres), its defences survive in the form of a bank measuring 30 feet (9 metres) wide and up to 5 feet 9 inches (1.8 metres) high, surrounded by a ditch. Access was gained via two gateways, one at the north-east and one at the south-west. Both survive as causewayed gaps in the ramparts, flanked by inward turning banks.

During the English Civil War, The Trundle was used as a military base by vigilantes known as Clubmen. In 1645, a group of around 1,000 Clubmen gathered on the summit to protest against the demands of Royalist and Parliamentarian forces. Both sides expected the people and parish administrators to provide free quartering for their troops and to keep their garrisons supplied with free food and equipment.

This was one of several illegal meetings held by the Clubmen across Sussex and Hampshire and their protests and actions were viewed by Parliament as 'an inconvenience'. In response Colonel Norton (Idle Dick), a friend of Oliver Cromwell, was ordered into Sussex with a thousand cavalrymen to prevent any further 'inconvenience' arising. Norton tricked the Clubmen into gathering at Walberton, where his cavalry surprised them and killed several men attempting to ring the warning bell. Most Clubmen fled but two ministers were taken prisoner and number of stragglers were executed to deter further Clubmen activities.

During the sixteenth century, a beacon for warning against attack from the French was erected on the summit; in 1745 it created a widespread panic among the locals when it was mistakenly lit. During the Second World War, military VHF Direction-Finding Stations were located within the western and north-eastern sectors of the earthworks. Each station contained four wooden masts, one of which survives in the north-eastern compound. The concrete foundations of a Nissen-style corrugated-iron shelter erected in the northern part of the hillfort also survives along with military foxholes and slit trenches dug into the ramparts.

The early Iron Age Chanctonbury Ring hillfort, near Findon, has an oval-shaped outer ring measuring 550 feet (167 metres) by 400 feet (121 metres) with entrances in the

Chanctonbury Ring hillfort. (DT)

south-west and east of the ring. The hill rises 784 feet (238 metres) above sea level with commanding views over the weald. During the Roman occupation of Britain, at least two temples were erected within the enclosure, a common military practice used to assimilate pre-existing cultures into their own.

In the reign of Elizabeth I, a beacon was erected on the crest of Chanctonbury to warn of the approach of the Spanish Armada. In 1760, the Goring family planted a ring of trees within the earthworks; these were destroyed during the great storm of 1987 and replanted in 1991 by Goring's descendants.

Although now mostly ploughed out, Ditchling Beacon, also known as Ditchling Castle, south of Ditchling village, was one of the largest Iron Age hillforts with a single rectangular bank and ditch that measured 147 feet (45 metres) by 112 feet (34 metres).

A more unusual fort is the rare late Iron Age Philpots Promontory Fort, also known as Philpots Camp. Only 100 promontory forts are recorded nationally. These naturally defendable sites are adapted as enclosures by the construction of one or more ramparts across the neck of a spur to divide it from the surrounding land.

The site stands 475 feet (145 metres) high and covers an area of 15 acres. It is located on a triangular sandstone spur in the High Weald, 1,600 feet (500 metres) north-west of Philpots Farm. The northern side is defined by a single bank and ditch with the western and south-eastern sides defined by steep, sandstone cliffs and boulders, reaching a height of 49 feet (15 metres).

The most historic and largest Iron Age hillfort on the South Downs is Cissbury Ring, enclosed by a wall and ditch 1 mile in circumference. Constructed around 400 BCE, the wall comprised 8,000 timbers and 60,000 tons of earth stood 30 feet (9 metres) above the ditch, which was 11 feet (3.3 metres) deep. Access was gained via two entrances,

View from Ditchling Beacon.

Philpots Promontory Camp. (© Ian Mulcahy)

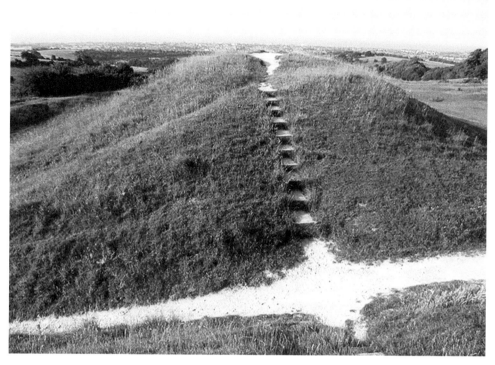

Entrance to Cissbury Ring hillfort.

one at the eastern corner and the other at the southern end. Archaeologists believe the fort was completed in just one summer using several thousand people to build and defend it. Cissbury remained in use for over 300 years, reflecting the strategic importance of the site and the threat that invasion posed.

Archaeological evidence suggests the Romans further reinforced Cissbury to defend against invading Saxons, who in turn used the fort to protect a coin mint. As with many hillforts, Cissbury became a beacon site in Tudor times, and part of an early warning system that ran the length of the south coast. During the Second World War, anti-aircraft guns were located along the ridge within the fort and during 1940, a large anti-tank ditch was dug around the base of the hill.

Another unique hillfort, Highdown Hill, may be found just north of Ferring on the West Sussex coast. A Bronze Age fortified settlement, it was transformed during the Iron Age into a typical oval-shaped fort enclosing an area of 12 acres with two simple causeway entrances. Unusually, it was defended by a single bank and a clay-lined ditch – the clay lining suggests it was used as a moat.

Though it was in constant use from prehistoric to the Saxon times, compared with Sussex's other hillforts Highdown is small, standing 266 feet (81 metres) high. Purported to be the burial site of the Saxon kings of Sussex, legend states the first king of the South Saxons, King Aelle, was buried there after his death in 516 CE, at the Battle of Mount Badon between Celtic Britons (led by King Arthur) and Anglo-Saxons (led by Aelle).

During the Second World War, a radar station was erected there, and several anti-aircraft guns were placed across the hill with slit trenches and machine-gun posts being dug into the ancient earthworks.

Iron Age hillforts afforded effective protection for the defenders during intertribal conflicts but when pitched against the might of the mechanised Roman army with its bolt throwers and catapults, they fared less well. During attacks, defenders would hurl stones, fire slingshots and throw javelins from the ramparts. The most vulnerable points of a hillfort's defences were the entrances and the Romans targeted these.

Using their shields as cover from airborne assault, the Romans gained entry by building fires and burning the gates. As a result, approaches to gateways became sophisticated. Elaborate gate-towers were built that enabled defenders to drop rocks from a height onto the heads of attacking enemies. Newer gates were set back from the edge of the ditch and approach routes wound their way up towards the gate. As they moved along the approach route, a series of walls began narrowing the gap that slowed attackers down and made them easier targets. At the Trundle, excavations showed that around 200 BCE the gates had been made stronger, and the approach passages were lengthened and inverted.

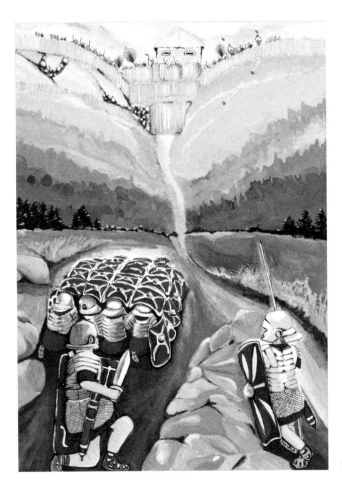

Romans attacking hillfort. (SD)

The arrival of the Roman army with their new building techniques and technologies paved the way for the next phase of development in Sussex's military defences. The military used the hillforts as operational bases while they established themselves. In time, having subjugated local tribes, they began to expand and develop existing towns, fortifying them with large walls and buildings.

At Noviomagus Reginorum (now known as Chichester), extensive fortifications were built on the north side of the city to protect the capital from raiding Britons, who in the early stages of the conquest had retreated in large numbers to the hills and impregnable forests of the Weald. Today all that remains of Rome's military presence at Chichester are a few fortified walls and bastion towers.

One of the most noteworthy signs of the Romans' military efficiency that remains today is the mighty 'Stane Street'. Stane Street ran 55 miles from the eastern gateway of Chichester in one continuous straight line towards London as an embanked road with deep side ditches built in 70 CE. Most Roman roads were linked to existing towns for economic and commercial purposes. Stane Street, however, was designed solely for moving large numbers of troops and for sending messages quickly and efficiently. Taking no account of established trackways, it was unlike any other road in Britain and created the shortest and most direct route between London and the South West. Devoid of any Roman towns or villages, the routes were punctuated every 12 or 13 miles (a day's march) with military posting stations.

The Romans built a great chain of forts called the Saxonicum (Saxon Shore) to protect the Roman population and important sites from the seaward threat posed by Saxon and Frankish raiders. Anderitum, built 290 CE, was the largest of the nine forts constructed, and was used by William the Conqueror as his headquarters in 1066. He later converted it into Pevensey Castle.

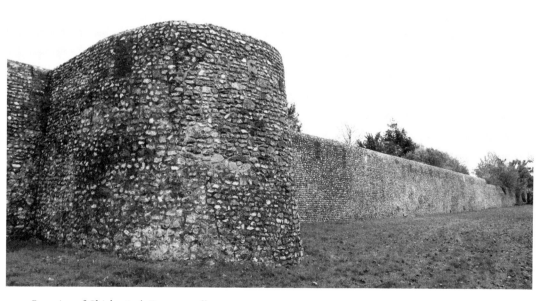

Remains of Chichester's Roman wall.

Built on a peninsula rising above the coastal marshes, the fort was the home base for the Roman naval fleet the 'Classis Anderidaensis'. Today two-thirds of the fort walls with its D-shaped towers remain at their original height of 30 feet (9 metres), enclosing an area of 10 acres. Two gates also remain: the large West Gate, which was the main entrance, and the smaller arched East Gate.

The Romans dominated and protected Sussex until their departure between 400 and 410 CE. They garrisoned legions and naval forces throughout what today is East and West Sussex. They also garrisoned Germanic and Gallic mercenaries along the more vulnerable

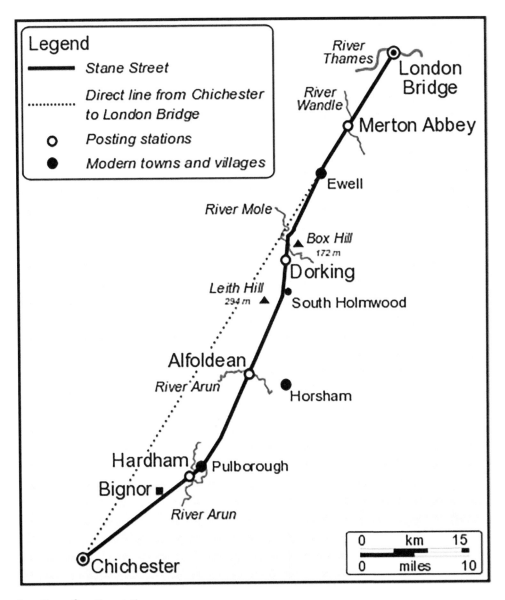

Locations of posting stations.

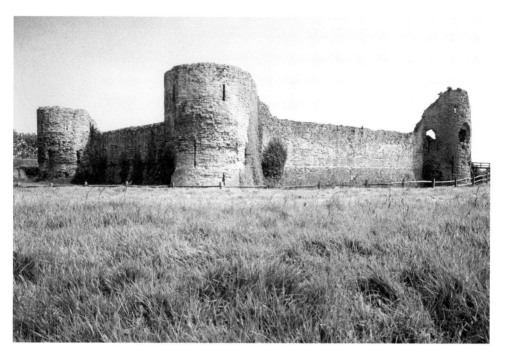

Saxon shore fort, Pevensey.

stretches of coastline as part of the Saxon Shore defence system, supporting the Classis Anderidaensis with auxiliary ships from their own fleets.

When the Romans left, their fortifications disappeared as the Saxons arrived and used the Roman defences as a source of building materials for their churches. The Saxons placed little importance on defending the coast, and in time Anderitum fell into disrepair and became a vulnerable shell.

The Saxons were great users of timber, employing traditional building methods developed in the lands they originated from: Holland, Denmark and Germany. In time, they would be threatened by the Danish Vikings and in response the Anglo-Saxon king, Alfred the Great, ordered a series of fortified towns called burhs to be built across his kingdom of Wessex (modern counties of Somerset, Wiltshire Hampshire and Dorset). Many burhs were built on former Roman towns or Iron Age hillforts, others were new burhs designed using a grid pattern of streets, which imitated the Roman style of town planning.

Alfred favoured Roman towns because they were sited at key points along the old Roman road network, enabling effective communication between Saxon towns. Additionally, Roman towns had earthwork defences that could easily be repaired and strengthened, and some had basic fortifications in place such as walls and towers.

In Sussex, burhs were constructed at Hastings, Lewes, Burpham, Pevensey and Chichester, located close enough to aid one another in times of attack. They were designed to act as fortified muster points where troops could rally before marching out to engage the enemy, protecting villagers and farmers.

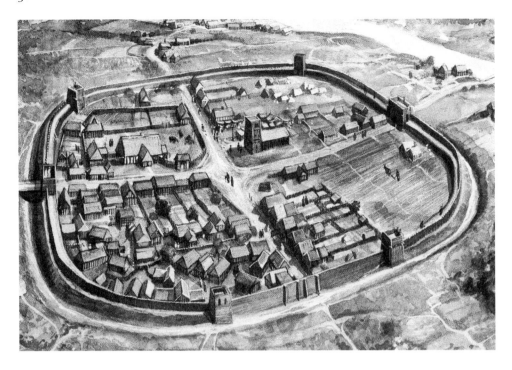

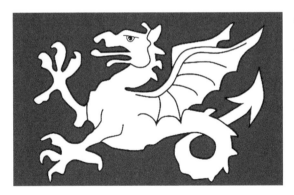

Above: Anglo-Saxon burh.

Left: The Wyvern of Wessex.

Because of their preference for timber construction, little remains of Alfred's burhs, although many modern streets at Chichester follow the Saxon street plan. At Wareham, the remnants of the defensive ditch and bank that surrounded the burh remain and, at Burpham, remnants of the burh can still be seen.

The white wyvern (two-legged dragon) became the emblem of Wessex, the territory of the West Saxons, and was the banner under which King Alfred the Great defeated the Vikings at Edington. It was on the banner carried by King Athelstan when he beat the combined armies of the Scots, Welsh, Norse and Irish at Brananburgh in 937 and flown by King Harold II when he bested the Norse army at Stamford Bridge in 1066. It was used again when he lost to the Duke of Normandy at Sussex three weeks later. The symbol of Saxon unity, the dragon remains on the Welsh flag today.

3. Stone Castles to Device Forts

The next defensive fortifications to appear in Sussex's landscape were the strong, imposing, stone-walled Norman structures. Unlike the symmetrical forts erected by the Romans, Norman castles were individual developments of irregular shapes that, like hillforts, hugged the contours of the land they were built upon. They were symbolic of the power and might of their builders and served several purposes: to hold down conquered territory, to command and control a region, and to serve as a warning to the Saxons that any rebellion would be met with military force.

Norman castles were private fortified residences granted to the king's most trusted companions, who were responsible for securing control of their area and facilitating unhindered access with Normandy. There was no standing army and the local population were required to provide the 'castle guard' on a rota basis and formed part of the national defence system.

Following the Norman invasion of 1066, William the Conqueror started a programme of castle-building. First, temporary motte-and-bailey castles were built that enabled them to quickly control the Saxons. The motte was a hill, either naturally occurring or man-made, upon which was placed a tower, known as a keep. Earth required for an artificial mound was taken from a ditch, dug around the motte or around the whole castle, which was sometimes filled with water. The outer surface of the mound was covered with clay or strengthened with wooden supports.

The motte overlooked the bailey, an enclosed courtyard surrounded by a wooden palisade. Within the bailey was a large hall, stables, cattle sheds, a chapel, barracks, merchants' shops and a living area for servants and craftsmen such as blacksmiths and millers among others. Castles sometimes had an inner and an outer bailey and when a castle was expanded, a new bailey with a wall was added. Access to the bailey and the motte was via timber drawbridges in the palisade that could be detached as a last means of defence.

Motte-and-bailey castles were quick to erect and easy to repair as they were made of wood. Being constructed of timber meant the size of the castle was restricted. They were also flammable and vulnerable to rotting. As soon as William had England under his control, he began building huge imposing stone keep castles that would last for centuries.

In 1066, castles were unknown in England, but the country was quickly teeming with them. According to one conservative estimate based on the number of surviving earthworks, at least 1,000 had been constructed by the end of the eleventh century. Today Sussex's countryside and coastline are studded with the stone remains and earthworks from centuries of castle-building.

Consolidating their power over the Anglo-Saxons of England, the Normans were experts at maintaining control, achieved by splitting Sussex into six different districts or

'rapes': Arundel, Bramber, Chichester, Hastings, Lewes, and Pevensey. At the heart of each rape was its castle and seat of local administration.

Arundel Castle sits on an artificial mound over 100 feet above the dry moat below, and is a spectacular example of a motte-and-double-bailey-style castle. Home of the Dukes of Norfolk for over 600 years, the Norman lord Roger de Montgomery originally built the castle in 1068. The original twelfth-century keep was refurbished in a fairy tale Gothic style during the nineteenth century and includes a small chamber occupied by Queen Maud, granddaughter of William the Conqueror when she returned from France to unsuccessfully claim the throne of England.

Bramber Castle is an early Norman motte-and-bailey castle built in 1070 by William de Braose, who fought alongside William the Conqueror at the Battle of Hastings. Bramber Castle remained in the de Braose family for over 250 years before a dispute with King John in 1208 saw William de Braose, 4th Lord of Bramber, outlawed and his family thrown into prison, where his wife and eldest son were starved to death in the dungeons of Windsor Castle.

The brutality of King John towards his one-time ally shocked the lords and contributed to the First Barons' War of 1215–17 (a group of rebellious landowners commonly referred to as barons) that culminated in Magna Carta. De Braose's younger son regained the family estates but the family never regained the same levels of power and prosperity. Parliamentarian troops besieged Bramber during the Civil War and today, among the ruins, only the huge gatehouse tower remains as a clue to the imposing nature of the former stronghold.

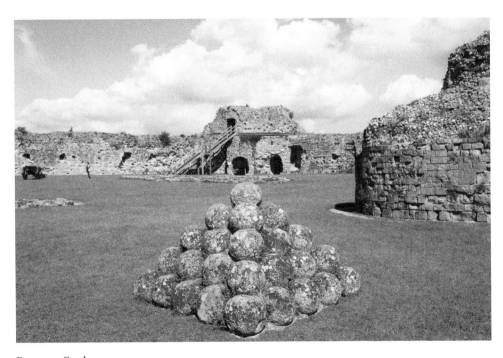

Pevensey Castle.

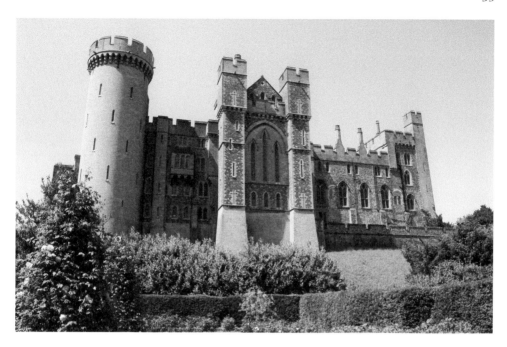

Above: Arundel Castle.

Right: Remains of Bramber Castle.

William de Braose.

At Chichester all that remains of the motte-and-bailey castle built by Roger de Montgomery are the remains of the motte, which survive as an oval-shaped artificially raised mound in the town's recreation park. The remains of a surrounding dry moat and a bailey survive as in-filled or buried archaeological features. Unusually for an urban castle, Chichester was used as a court and jail during the early thirteenth century. However, during the First Barons' War the castle, despite being well provisioned for a long siege, was captured in 1216 and surrendered to the French. Recaptured by the English in the spring of 1217, Henry III ordered the castle's destruction to prevent it falling into the hands of the invading Prince Louis, Dauphin of France.

Hastings Castle, built in the immediate aftermath of the Norman invasion, was one of the first of many wooden motte-and-bailey fortifications constructed across England. William left Hastings Castle under the control of Humphrey de Tilleul, an engineer whose castle-building ability made him an important asset to the Norman war effort. In 1069 the king granted the castle to Robert, Count of Eu, one of his closest supporters who rebuilt the castle in stone.

Built upon sandstone cliffs, the castle suffered from coastal erosion, which, by the thirteenth century, also ended the viability of Hastings as a port, resulting in a general decline in its economic worth and military importance. As a result, infrequent repairs and repeated attacks by the French in 1339 and 1377 left the castle in ruins.

Lewes Castle was one of the first stone keep castles to be built in England and is an excellent example of a double motte-and-bailey castle. Originally built by William de Warenne, a Norman baron in 1067, it was rebuilt in stone in 1100 when a second mottle was added.

Remains of Chichester's castle motte.

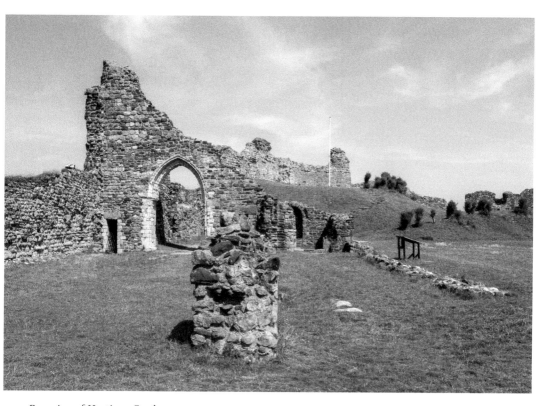

Remains of Hastings Castle.

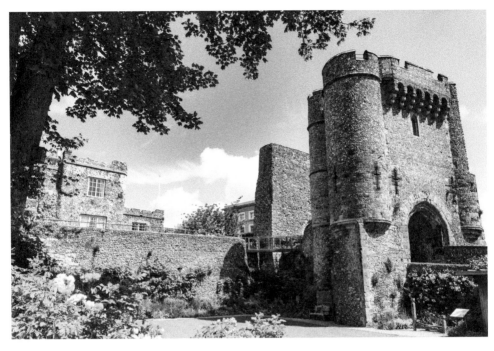

Lewes Castle. (DT)

In 1264, Lewes Castle was embroiled in the national politics of another Civil War, the Second Barons' War, when Henry III's forces moved into the town in anticipation of engaging the rebel army of Simon de Montfort. In response, the castle supplied troops who fought at the Battle of Lewes.

In 1381 the castle was stormed during the Peasants' Revolt by rioters who stole wine and stone from the fortification. As a punishment, Lewes Castle became a prison and during the fifteenth century, the castle's importance waned, and it became a warehouse for wool. Repairs were neglected and its stone was removed and robbed during the seventeenth century for use elsewhere, causing the castle to fall into ruin.

The Count of Mortain, William the Conqueror's half-brother, built Pevensey Castle to act as the administrative centre for the area. Re-using the Roman wall as the outer bailey for the new castle, a ditch defined an inner bailey and earth rampart, surmounted by a timber palisade. Though it was besieged four times during the Middle Ages, it was never taken by force.

In addition to the rape castles, castles were built for other barons and high clergy. Amberley Castle was erected in the twelfth century and fortified in 1377. It had a rhomboid-shaped stonework enclosure, surrounded by high curtain walls with internal towers in each corner, a hall and a gateway. It was used as a fortress by the Bishops of Chichester. Today, only the walls, gateway and two of the towers remain.

Many of Sussex's temporary castles were replaced by stone ones serving as secondary residences or fortified hunting lodges belonging to the lords of the more prominent castles. In time, most fell into disrepair. Robbed or demolished, their materials were

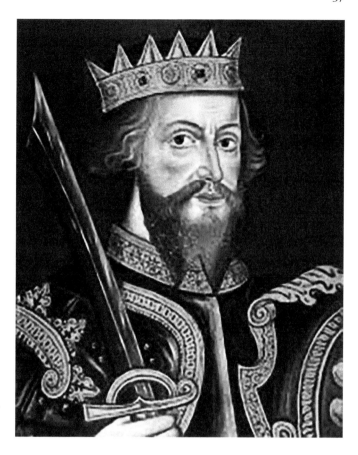

Right: William de Warenne.

Below: Amberley Castle.

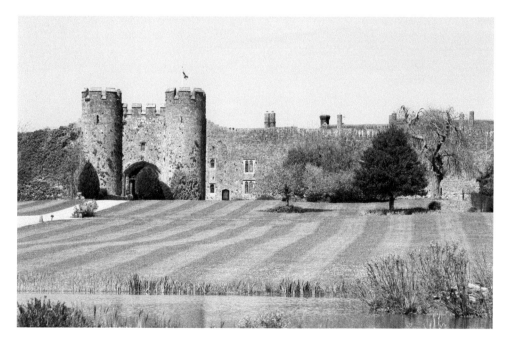

used for roads. Today, castles such as Fulking, Hartfield, Rudgwick, Rogate, Sedgewick, Shoreham, Verdley, Midhurst, Aldingbourne, Burghlow, Caburn, Ewhurst, Old Erringham and Pulborough exist only as follies, broken foundations or earthworks.

Fortifications were not restricted to castles; manor houses, towns, cities and ecclesiastical sites were often fortified with walls, towers and gatehouses. Examples of such defences can be seen at Crowhurst, Petworth, Rye, Winchelsea, Battle Abbey, Hastings, Chichester and the priories of Lewes, Michelham and Wilmington.

As the Middle Ages progressed, the changes in warfare saw wars once more being decided upon the field rather than by the capturing of castles. The development of artillery and the break-up of the feudal system led to the decline of Norman-style castles. New methods of construction adopted a more basic and less formidable design. Their function was not to hold down a newly conquered territory or command a region but to offer protection for a lord and his army. These armies would have been composed of hired mercenaries rather than the local populace, forming the castle guard. Defensive towers such as Ypres at Rye were fortified with 'gun gardens' – secure walled areas that housed cannons and munitions.

Bodiam Castle, with its iconic moat, was originally built in 1385 by Sir Edward Dalyngrigge, who designed the castle as a defence against invasion by the French during the Hundred Years' War and as an inviting home with landscaped gardens. It is a quadrangular design and, unusually, features chambers on the outer walls with towers on each of the entrance points and at the corners.

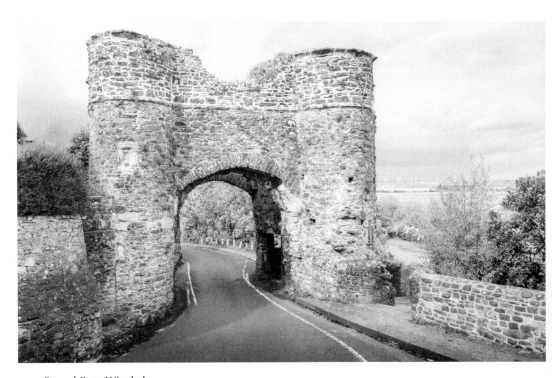

Strand Gate, Winchelsea.

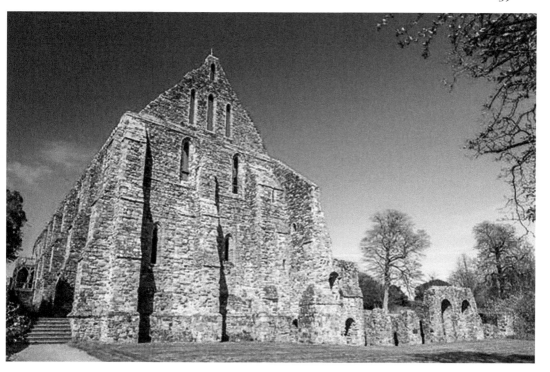

Battle Abbey.

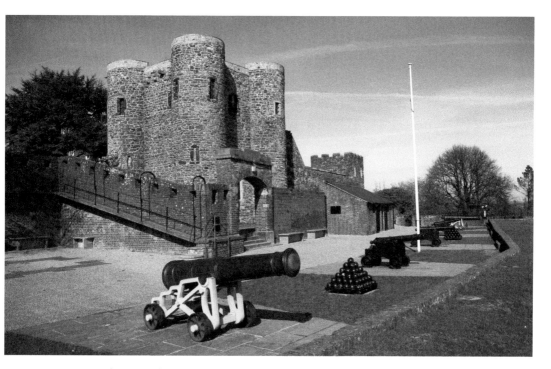

Ypres Tower and Gun Garden, Rye.

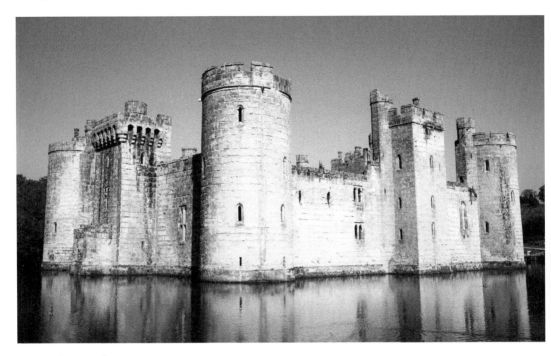

Bodiam Castle.

Amidst fears of reprisals from France and Germany following Henry VIII's departure from the Catholic faith, castle-building was revived. Similar to medieval castles, Henry's castles were specifically designed and used for military purposes. They were low and squat and housed small garrisons with large cannons mounted on thick bastions and walls, and were unlike anything built before in England. Artillery was becoming more destructive and exposed walls of traditional castles pounded by heavy cannon were easily reduced to rubble.

Built along the coastline of England from Hull to Cornwall, these castles formed a defensive chain protecting the key ports of England and were the precursors to later star forts. In Sussex, only one such castle in the chain was built at Camber. Completed in 1554 to defend Rye Haven, Camber Castle was the first in England to have been built to be defended by cannon and was second only to Deal Castle, Kent, in size.

Symmetrical, and in the typical Tudor rose design, its four D-shaped bastions correspond to the points of a compass. The walls were 11 feet (3 metres) thick, faced with sandstone, and stood 20 feet (6 metres) high with a central tower rising up 30 feet (9 metres). It housed eight soldiers and seventeen gunners. Advances in warfare were racing and the castle's design was obsolete by the time of its completion. During the 1550s, its military value became ineffective as a defence when the River Rye silted up and the sea receded beyond the cannons' reach. Today, just the shell of the landlocked castle remains.

The feared invasion never happened and by the end of the Tudor period, a transition from the declining castle to the stately home took place. Some houses preserved their feudal heritage in their title and included defensive features such as drawbridges, moats, gun loops and crenelated walls. The finest examples in Sussex are Herstmonceux and Cowdray castles.

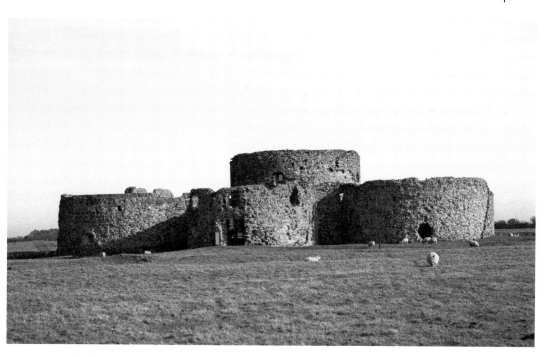

Camber Castle.

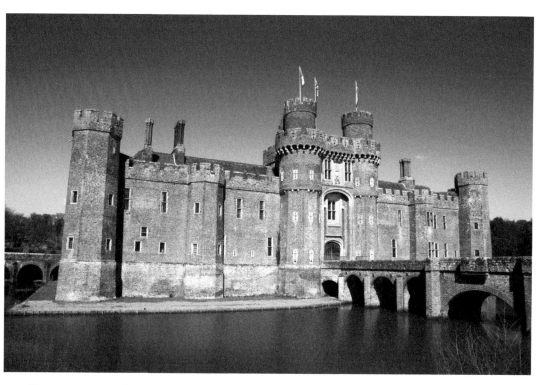

Herstmonceux Castle.

In 1588, during the reign of Elizabeth I, Spain sparked concerns of invasion. An early warning system of fire beacons was installed across Sussex and coastal batteries were manned. When the threat passed, Sussex's coastal defences were largely neglected until the middle of the eighteenth century when Britain was once more at odds with France and her allies and invasion fears returned.

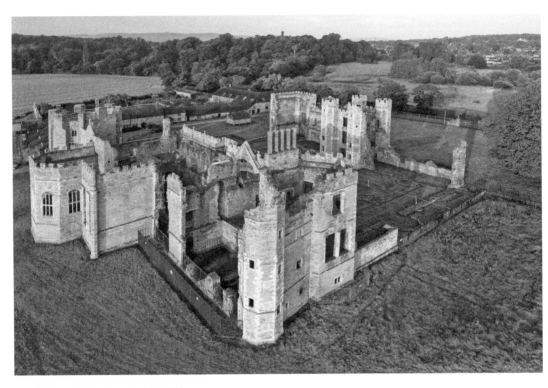

Ruins of Cowdray Castle. (DT)

4. Gun Towers to Nuclear Bunkers

Field Marshal Sir John Ligonier had a long and distinguished career in the British army and was made Commander-in-chief in 1757. He stood down as Commander-in-chief in 1759 and became Master-General of the Board of Ordnance, responsible for all British artillery, engineers, fortifications, military supplies, transport and field hospitals.

Following a review of the county's fortifications he immediately replaced the traditional gun gardens (parapets and ramparts formed of compacted earth and protected at the rear by a strong, wooden stockade that was manned by four soldiers and seven 18-lb cannons) with lunette forts (brick-built, crescent-shaped fortifications, a half-moon-shape frontage angled towards an expected attack which in time became redans with V-shape frontages).

France's revolutionary soldiers led by Napoleon Bonaparte had to abort a planned invasion of England in 1797, as they had when led by General Hoche the previous year. This resulted in additional defences being put into place, regular and militia troops being garrisoned across the county and new gun batteries being built in Selsey and Bognor.

Between 1805 and 1808, seventy-four Martello towers – round structures 40 feet (12 metres) high with walls 8 feet (2.5 metres) thick that made them resistant to cannon

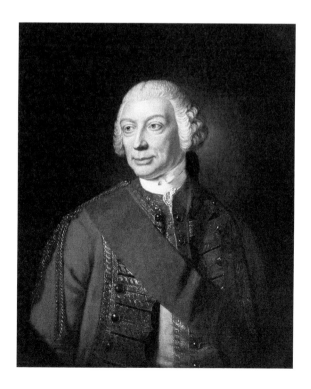

Field Marshal John Ligonier.

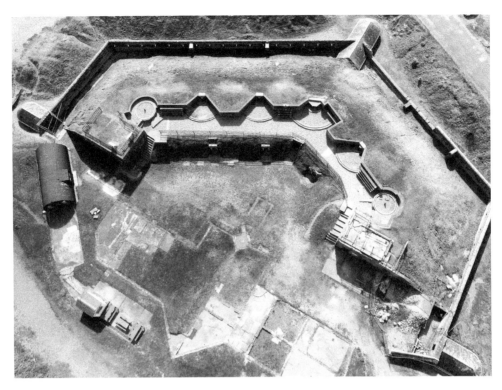

Shoreham Lunette Fort. (DT)

fire – were constructed along the Kent and East Sussex coast. Each tower was fitted with a platform for a single heavy artillery piece, mounted on the roof, providing a 360° vantage point. Inside were three floors. The lower housed food supplies and a water tank, the middle supplies and a powder store, and the upper was the office and men's quarters. Of the forty-six towers built in Sussex, only ten remain and are viewable: No. 28, Rye Harbour 'Enchantress Martello Tower'; No. 30, Rye; No. 55, Norman's Bay; Nos 60, 61, 62, 64, Pevensey Bay; No. 66, Eastbourne; No. 73, 'The Wish Martello Tower', Eastbourne; and No. 74, Seaford. The rest were lost to the sea or demolished.

Eastbourne Redoubt was one of three 'grand redoubts', an eleven-gun tower known as a circular fort, built in 1805 to act as barracks and stores depots for the Martello chain, as well being a formidable fortress in its own right. The second redoubt was located in Dymchurch, Kent, but the third, earmarked for Rye Harbour, was built at Harwich, Essex. Each fort measured 224 feet (68 metres) in diameter and was built almost entirely of brick. The lower tier comprised a ring of twenty-four casemates (vaulted chambers), which opened into a central parade ground. Used for storage, casemates were also used to house ammunition, the cookhouse, detention rooms and cells.

Inland and along the coast, new barracks ranging from small tented encampments to wooden huts and large brick buildings were constructed to house 20,000 soldiers sent to join existing troops. Lieutenant Colonel John Brown, Assistant Quartermaster-General, conceived the idea of a physical barrier, the Royal Military Canal, to prevent Napoleon's

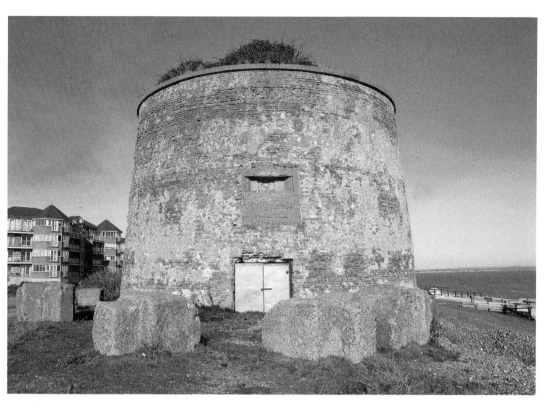

Martello Tower 64, Eastbourne.

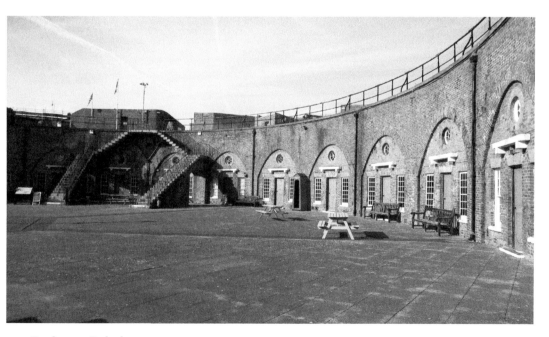

Eastbourne Redoubt.

troops moving inland from the coast. Constructed between 1804 and 1809, it ran for 28 miles from Hythe, Kent, passing by Winchelsea, Rye, and Iden Lock, ending at the village of Pett Level, East Sussex.

Following the Napoleonic Wars, the nation's coastal defences were once more neglected until the threat of invasion re-emerged. Responding to the French increasing the strength of their navy, new experimental forts were built at Littlehampton in 1854 and Shoreham in 1857. The forts were built after the introduction of rifling in guns, which increased their range and accuracy. Flaws in the design of Littlehampton Fort were corrected at Shoreham Fort and later used in building new fortifications in Portsmouth. Littlehampton remains intact, preserved under sand dunes, while Shoreham is being restored by the Friends of Shoreham Fort.

In 1860, Prime Minister Lord Palmerston accepted recommendations from the Commission on the Defence of the United Kingdom, which heralded another phase of defensive works. A variety of new defences were built on several key areas of the British, Irish and Channel Island coastlines, and military bases.

The largest fort ever built in Sussex was constructed at Newhaven. Completed in 1871, Newhaven Fort was armed with two 9-inch rifled muzzle-loading guns on innovative Moncrieff disappearing carriages, the only one in the UK.

While the threat of invasion did not materialise, troops continued to exercise upon the downs, and camps and barracks continued to be built. Drill halls came into existence following the formation of large numbers of volunteer units in 1859–60. These units required a secure location to store weapons and a large covered area to practise drilling. Drill halls were a common feature in almost every British town and city as 'Territorial Army centres'. Today drill halls still exist at Church Street, North Lane and Gloucester Mews, Brighton; Hatherley Road, St Leonard; Denne Road, Horsham; Eastbourne Road, Pevensey; and Sturton Place, Hailsham.

Fortifications along Sussex's coast were once more abandoned. In time, most of the camps and barracks disappeared, leaving only remnants such as the large crenelated entrance and original flint walls of Roussillon Barracks at Chichester.

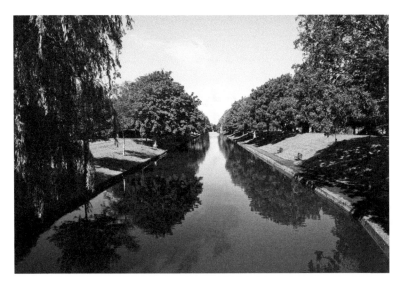

The Royal Military Canal.

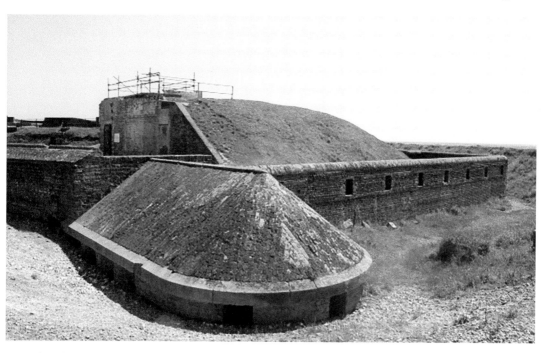

Shoreham Fort.

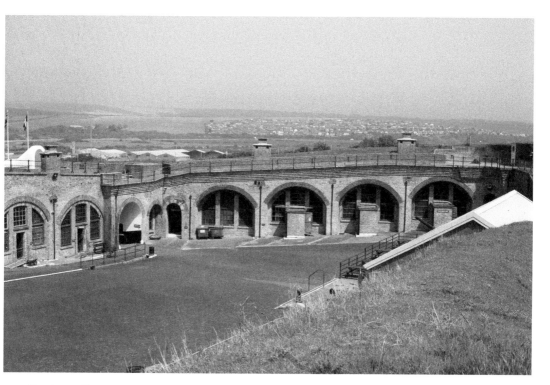

Newhaven Fort.

Former Drill Hall, Down Road. (© Oast House Archive)

The commencement of the First World War saw the next significant phase of defensive works in Sussex. Invasion wasn't considered a threat, unless the Royal Navy was lost. As a result, only Newhaven Fort received any significant defensive armament. It had two 6-inch breech-loading naval guns installed (although these were replaced in 1941 with a battery of 6-inch coastal guns) and two light 12-pounder guns for defence against torpedo boats, it being thought that this was all that was required to deter any hostile ship. Shoreham Fort had its smooth-bore guns replaced by two 80-pound and three 60-pound rifled guns, while Littlehampton Fort became a workshop manufacturing hulls for seaplanes.

Inland a line of defence was created, trenches and breastworks were dug across fields and cliffs and along the coast and gun emplacements were built. New defences, searchlights, listening and machine-gun posts and anti-aircraft guns were deployed. A forerunner of radar, the 'Sound Mirror' was built to provide early warning of incoming enemy aircraft. Other new forms of defence in use were the airfields and airship outstations. Bridges, tunnels, road junctions and railways were rigged with explosives to destroy the location, preventing its use by an invading force.

During the Second World War, significant differences in the construction and deployment of anti-invasion defences were made. Emphasis moved from a line of defence approach to defence in depth approach. A new network of defensive 'stop lines' along rivers and other obstacles were created to slow or halt an advancing enemy. Concrete Pillboxes, anti-tank traps (ditches 18 feet (5.5 metres) wide and 11 feet (3.4 metres) deep) dragon's teeth (cubes made of reinforced concrete 5 feet (1.5 metres) wide) were placed in rows, and barbed-wire entanglements were deployed along with selected belts of land, seeded with mines to deny the enemy use of open land.

Former Drill Hall, Hatherley Road. (© Oast House Archive)

Roussillon Barracks.

50

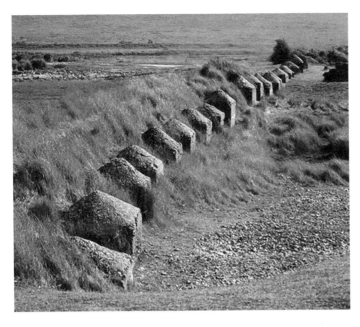

Left: Second World War anti-tank blocks, Cuckmere Haven.

Below: Second World War pillbox, Cuckmere Haven.

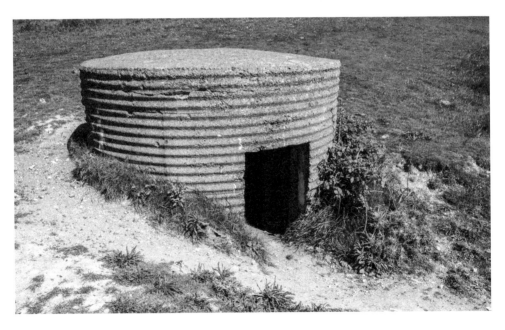

Along the coast, emergency coastal batteries fitted with guns salvaged from scrapped First World War naval vessels were constructed to protect ports and likely landing places. Coastal waters were mined, and beaches blocked with entanglements of barbed wire, fences of straight wires and 'Admiralty Scaffolding' – fences of scaffold tubes 9 feet (2.7 metres) high placed to prevent tanks getting ashore at low tide. The beaches were also defended by various types of pillboxes (concrete or brick bunkers equipped with

loopholes through which to fire weapons) sited at ground level to provide crossfire; others were placed high up, making them harder to capture. Searchlights were installed along the coastline to illuminate the sea surface and the beaches.

Advancements in aviation placed greater emphasis on anti-aircraft defences, barrage balloons, anti-aircraft guns and searchlights. Civil defence became an issue and public and private air-raid shelters were constructed.

RADAR stations were used to locate enemy aircraft and at Ashdown Forest, Crowborough, in 1942 the world's most powerful transmitter was being used to conduct 'black propaganda', operations which confused and damaged the German war effort by giving them false directions and information. Located in a secret underground bunker, the transmitter, code-named Aspidistra, could switch German radio frequencies to British frequencies without them noticing, flooding Germany with false propaganda.

Aspidistra aired broadcasts posing as official German military radio stations in France and civilian stations in Berlin and Hamburg. In addition, it was used to disrupt German night fighter operations against allied bombers over Germany. German radar stations guided their fighters by broadcasting the movements of allied bombers en route to Germany. Aspidistra misdirected the German fighters using German-speaking RAF operators who sent fake instructions directing them to land, or to move to the wrong sectors.

During German bombing raids, the Luftwaffe used their frequencies to guide their bombers to British targets by playing music allocated to each target. Knowing this, Aspidistra was used to trick the Luftwaffe into bombing the wrong target by playing the wrong piece of music. After the war, it was used by the BBC as a broadcasting station until it closed in 1986. Now a listed building, it is owned by Sussex Police.

In 1939, the navy requisitioned a holiday home on Heighton Hill, Newhaven, and renamed it Denton House. Sixty feet underneath it, they built a secret labyrinth of tunnels

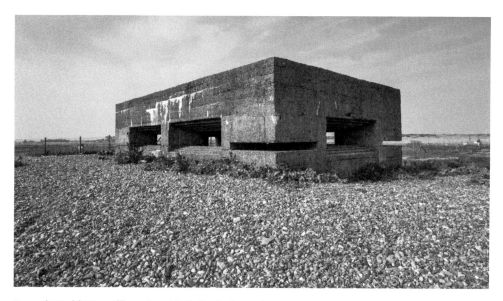

Second World War pillbox, Rye. (© Colin Anderson)

Second World War pillbox,
Bishopstone Station.
(© Roger Thomas)

to house HMS Forward, the naval headquarters for the maritime defence of the Sussex coast. Accessed only from inside the property, 122 steps led down to an air-conditioned communications centre containing offices used for wireless telegraphy, plotting and coding, telephone switchboards, signals distribution, sleeping accommodation and a canteen. The centre was defended by four pillboxes cut into the hillside above and a chicken coop, complete with twenty-four chickens, concealed an observation post and emergency exit accessed via the tunnels.

HMS Forward provided maritime surveillance of everything that moved on, under or over the English Channel from Dungeness to Selsey Bill and was also used to coordinate planning for the 1942 Dieppe Raid, the D-Day invasion, and nightly raids by commandos along the French coast, as well as many air and sea rescues. It was sealed up and abandoned following the war and was reopened in 1992 by the Newhaven Historical Society.

The peace that followed the Second World War soon gave way to the Cold War, and once more civil defence would feature in Britain's defensive thinking. The Civil Defence Corps (CDC), a civilian volunteer organisation, was established in 1949 to mobilise and take local control of affected areas in the aftermath of a nuclear attack. In the event of a nuclear strike, the Royal Observer Corps (ROC) were tasked with staffing 'Monitoring Posts', from which they would monitor radiation levels in their area.

Built to a standard design 15 feet below ground, the bunker was accessed via a surface hatch and ladder leading to a monitoring room containing bunk beds, a toilet, communications and monitoring equipment. Over 1,500 underground bunkers were built across the country, with each accommodating a team of three men. The posts were grouped in clusters of three to four and were connected via VHF and telephone to their Group's HQ, who in turn were connected to a sector HQ and regional HQ.

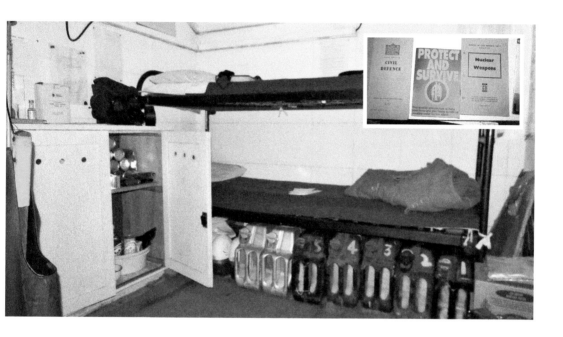

Above: Cuckfiled Nuclear Bunker.

Right: Royal Observer Corps' 50th Anniversary, Cuckfield Bunker, 1975. (© Ed Combes)

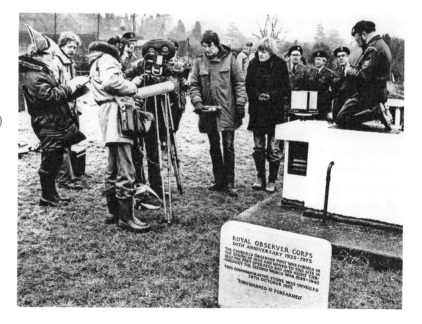

From the 1960s to 1992, the posts were decommissioned with many being removed or becoming dilapidated. One exception that remains is the bunker at Cuckfield. Fully restored by Mark Russell and Ed Combes, it provides insight into life during this period for the ROC and how a post would have operated.

Several Cold War emergency centres and local authority bunkers were built in Sussex to house key governmental, political, military and police personnel. Like the ROC posts, most are now gone; however, the West Sussex County Emergency Centre, Horsham District Council Emergency Centre and Hastings Borough Control Centre remain.

In an attempt to counter the Soviet bomber threat of the 1950s, the Air Ministry devised a secret and elaborate air defence radar system code-named ROTOR. The plan resulted in the creation of a massive network of underground and surface bunkers. In Sussex, bunkers were located at Eastbourne, Hastings, Shoreham and Wartling.

Of these, only Wartling, now a private residence, is accessible. One of a few nationally that remains in its original configuration, it was mothballed by the RAF in 1964 and sold to the Marquis of Abergavenny in 1976. Since 2004, a team of volunteers continue to perform remedial works on the bunker to stop it deteriorating further.

Cuckfield Nuclear Bunker open day.

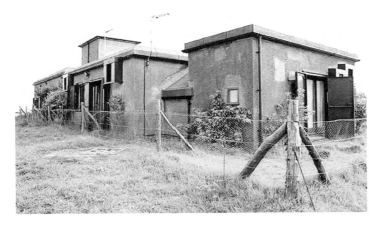

RAF Wartling Radar Modulator Building.

5. Furnaces, Foundries and Iron Mills

If the great campaigns of the Civil War were not fought in Sussex the county still influenced them. Sussex's twenty-seven furnaces, forty-two iron mills and cannon foundries were vital to both sides who wanted Sussex, and were prepared to fight for it. These foundries, including the Royal Foundry in St Leonard's Forest, produced much of the guns and shot used by Royalists and Roundheads during battles and sieges across the country.

On the 4 January 1642, King Charles I, intent on arresting five of his leading critics, entered the House of Commons with an armed guard and ignited decades of smouldering resentment. In the summer of that year civil war finally broke out in England.

The nation was divided between supporters of King Charles and his right to rule on his own without parliament, the clergy and the country's aristocracy and gentry. They vied against those who believed that laws and taxation should not be levied without the consent of parliament, the rising merchant class and religious puritans. The poor and lower classes who made up the mass of the population were not keen to support either side.

The king raised the Royal Standard at Nottingham on 22 August 1642 and the Civil War began. It ended with his execution on 30 January 1649.

Sussex escaped the worst ravages of the war. The county experienced sieges at Arundel and Chichester, and a bloody skirmish at Haywards Heath and several less notable military engagements.

Many wealthy Royalists lived in Chichester, including Sir Thomas Boyer, Christopher Lewknor and Sir John Morley. Opposing them were Henry Chitty, captain of the local militia, and William Cawley, Member of Parliament (MP) for Midhurst and Chichester.

Morley was frustrated because Chitty's men had taken control of the city's armoury and defences in the name of parliament. On the night of the 15 November 1642 a meeting was held at the Guildhall, Priory Park, ostensibly to reconcile the opposing factions. The meeting was a ruse, and while Chitty and his men were there Morley's men seized the armoury and captured the city's guns.

The following morning, the Royalist Sir Edward Ford, High Sheriff of Sussex, arrived to join the coupe with 1,000 men, including 100 dragoons (mounted infantry). Ford headed eastwards to take Lewes for the king. On route he established a small Royalist garrison at Arundel, while the bulk of his army continued towards Lewes. However, at Muster Green, Haywards Heath, they were intercepted by a Parliamentary militia from Lewes commanded by Colonel Herbert Morley, MP for Lewes and local Justice of the Peace. Although outnumbered four to one, they fought fiercely, killing 200 Royalists.

Left: William Cawley MP.

Below: Muster Green, Haywards Heath.

The battle soon became a route for the Royalists, and they were chased back into West Sussex by Morley's men.

In early December 1642 a detachment of 100 Parliamentary soldiers arrived at Arundel, one of the towns in the county appointed to be a store for arms and powder. Arundel Castle, which was under the control of the Royalist Howard family and defended by 100 men, was attacked by thirty-six soldiers who, having breached the castle gate following an explosion, surprised the defenders and forced them to surrender.

The remnants of Sir Edward Ford's forces arrived at Chichester on 21 December; on the 22 December, Parliamentary general William Waller arrived with an army of 6,000 men and besieged the walled city. A cannon placed in the tower of St Pancras Church, Eastgate Square, fired relentlessly into the city until the church was eventually destroyed. Following some minor skirmishes in the suburbs, the siege ended on the on 27 December when the city surrendered. Having rampaged through the city, Parliamentarian forces plundered the cathedral defacing statues, destroying paintings and smashing its stained-glass windows.

Henry King, the Bishop of Chichester, and his priests were forcibly ejected, and the city remained in Parliamentarian hands until the end of the war. In the cathedral evidence can still be found of the Parliamentary rampage. Some of the paintings of kings and bishops still show signs of the damage and the eyes of the portrait of King Edward VI are missing, having been picked out with a sword. Chichester remained a Parliamentary garrison until 1646.

General Sir William Waller.

Arundel remained in Parliamentary hands until early December 1643, when General Ford attacked and seized the town. The castle was besieged and bombarded by artillery, and three days later surrendered. It was re-occupied by 1,100 Royalist soldiers, including troops who'd escaped capture at the Cowdray and Petworth Houses garrisons, which had earlier fallen to Parliamentary forces.

On 19 December General Waller and his army of 6,000 men arrived at Arundel. The following morning, he attacked the north and south-west of the town. Thirty minutes of fighting ensued during which he seized the outworks and captured eighty men. Despite a determined Royalist cavalry charge, the town was taken by the Parliamentarians, and the Royalists retreated into the Castle. On 21 December, Colonel Morley's regiment and 600 of the Earl of Essex's cavalry joined the besieging forces.

There followed a seventeen-day siege during which marksmen, positioned in the upper parts of the castle, sniped at troops billeted in the surrounding town. To counter the marksmen two light cannons called 'saker drakes' were placed in the tower of Arundel Church, along with a unit of musketeers who rained down a murderous fire upon the battlements.

Parliamentarian reinforcements arrived from Kent, and many of the garrison's men deserted from what was becoming a lost cause. The castle's water supply had been stopped and by Saturday 23 December, the only water remaining was in the castle wells. A Royalist cavalry sortie on Christmas day was repelled, as were other skirmishes.

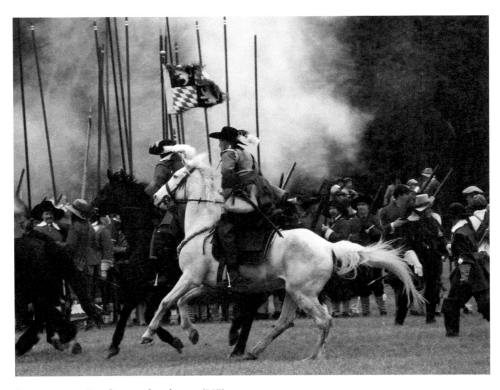

Re-enactment, Royalist cavalry charge. (MP)

Re-enactment, Royalist firing cannons.

Lieutenant-General Ralph Hopton, commanding fewer than 3,000 men, marched from Winchester to the relief of Arundel on 27 December. Waller moved his army to counter Hopton, leaving 1,500 men at siege. The opposing armies met on 29 December at West Dean, 4 miles north of Chichester. This was the largest gathering of hostile forces in Sussex since the Battle of Lewes. The Parliamentarians had superior numbers and following a brief skirmish, Hopton withdrew. Having failed to relieve the garrison, the Royalists offered terms of surrender, which were rejected. Waller refused to negotiate.

Waller bombarded the castle when heavy guns arrived from Portsmouth on 4 January. Typhus was rife inside the walls and food and water were in short supply. On 6 January terms of surrender were accepted by the Royalists and Waller took possession of 200 horses, 2,000 weapons, twenty barrels of gunpowder and £4,000. A total of 1,000 soldiers, including 100 officers and nineteen regimental colours, were taken.

Waller set about securing Sussex. The garrison of Chichester was increased to 800 men and a large magazine, stocked with 100 barrels of gunpowder, was established within Arundel Castle. The balance of power continued to shift, with minor scuffles taking place across the country as towns and villages were occupied by forces from both sides. At All Saint's Church, Hastings, a plaque marks the arrival of Parliamentarian forces in July 1643 under the leadership of Colonel Morley. He met no resistance, and took Hastings from Royalist control, capturing the town's guns. The church's rector fled but was later caught and thrown into jail. Parliamentary troops, having ransacked the church, stabled their horses there overnight.

Above: Re-enactors, Parliamentarian cavalry.

Left: Lieutenant-General Ralph Hopton.

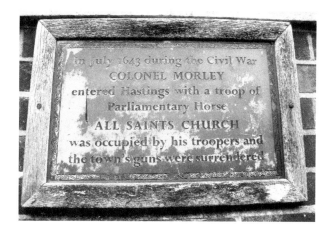

Right: Wall plaque, All Saints'
Church, Hastings.

Below: Greatham Church.

There was a minor clash at Greatham Bridge when fighting broke out as a group of local Royalists tried to prevent General Waller's army from claiming the bridge. Five Parliamentarian soldiers killed in the clash were buried unceremoniously, without coffins, in a mass grave within the grounds of Greatham Church. Their bodies remained undiscovered until the 1950s when the church vestry collapsed. Cannonballs left over from the battle are on display at Worthing Museum. While other churches were defiled, and stately houses and castles besieged, none saw the same level of violence as Chichester, Arundel and Haywards Heath.

6. Monuments and Memorials

Sussex has an interesting and varied collection of monuments and memorials which reflect the magnificent diversity of the people, animals, places and events that have contributed to its military heritage, and this chapter showcases the more unusual and interesting memorials and monuments to be found.

Few memorials reflect the breadth of that diversity more than the two memorials dedicated to the 12,000 Indian soldiers who, between 1914 and 1915, were wounded on the Western Front and hospitalised in Brighton. The Royal Pavilion, Corn Exchange and Dome were converted into military hospitals to care for them. At the conclusion of the war, the India Gate memorial was erected at the southern entrance to the Royal Pavilion on behalf of the people of India to show appreciation of the role played by Brighton in nursing their kinsmen. The Chattri memorial was built nearby on the Downs near Patcham to honour the Indian soldiers who died in Brighton's hospitals.

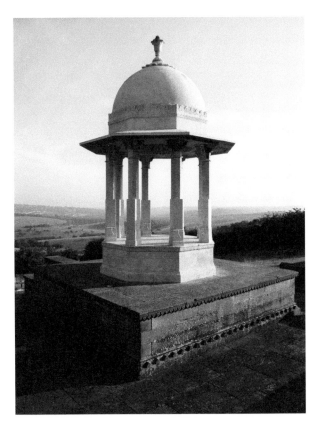

Chattri Memorial, Brighton.

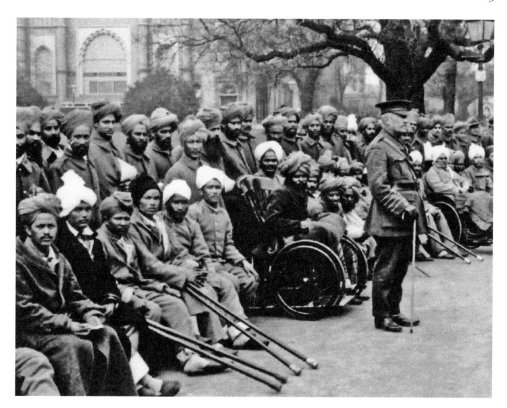

Above: Wounded Indian soldiers, Brighton Pavilion.

Right: Seaford station plaque.

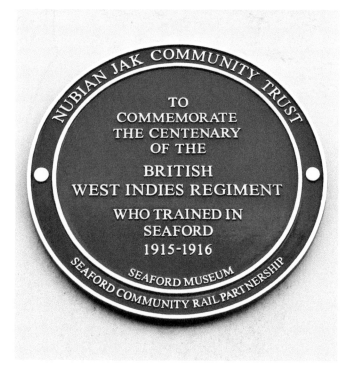

The British War Office originally did not want to use Caribbean soldiers, but their objections were waived during the recruitment process. In the end, 20,000 volunteers came to Britain to join the British West Indies Regiment (BWIR). The first of eleven Battalions was formed at Seaford in 1915 and, at St Leonards cemetery, a commemorative plaque remembers the 1st Battalion's formation and the nineteen soldiers buried there. At the railway station, a blue plaque commemorates all the men of the BWIR stationed at Seaford.

Beach House Park, Worthing, houses a unique memorial to Warrior Birds, unsung heroes of the National Pigeon Service, who lost their lives on active duty during the Second World War. The only memorial of its kind in Britain, the mound planted with shrubs and a rockery with streams and pools of water comprised two carved boulders and two stone pigeons; however, the pigeons were stolen and not replaced.

At Haywards Heath, a blue plaque now marks the birthplace of one of those warrior birds: Commando. Commando was awarded the animal equivalent of the Victoria Cross (VC), the highest and most prestigious honour of the British honours system, for gallantry in the presence of the enemy, to members of the British armed forces.

Commando was awarded the People's Dispensary for Sick Animals (PDSA) Dickin Medal for flying over ninety missions across occupied France. In 1942, he flew three missions in which he conveyed crucial intelligence to Britain from agents in France about the location of German troops, industrial sites and injured British soldiers. These missions earned him the award, which he received on 12 April 1945. His citation reads: 'For successfully delivering messages from agents in occupied France on three occasions: twice under exceptionally adverse conditions, while serving with the NPS in 1942.'

Haywards Heath is also the birthplace of another courageous resident, Arthur George Knight, who following schooling emigrated to Canada where, at the outbreak of the

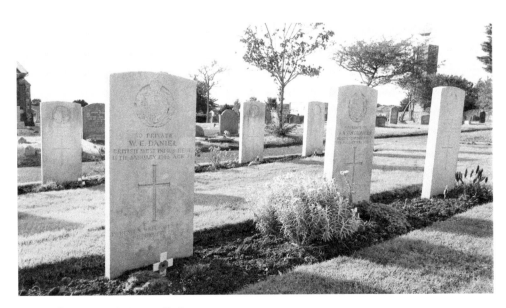

West Indian graves, St Leonard's Cemetery.

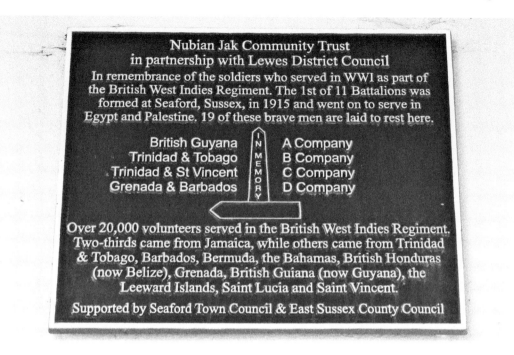

St Leonard's Cemetery memorial.

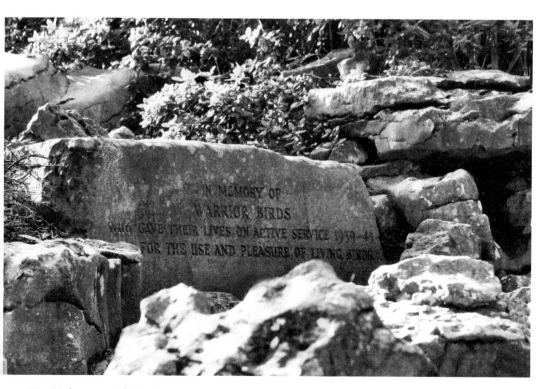

War Birds memorial, Worthing.

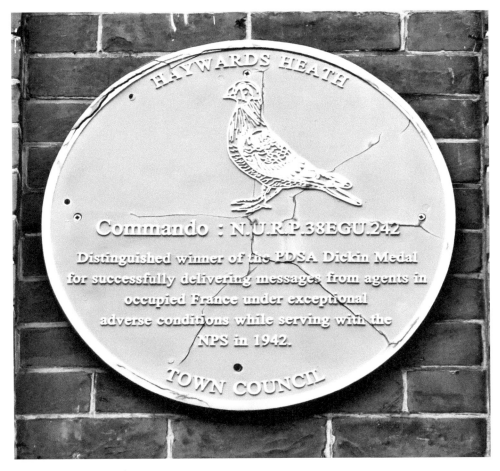

Commando's memorial.

First World War, he joined the 10th Battalion, Alberta Regiment, Canadian Infantry. He was one of seven Canadians awarded the Victoria Cross for their actions at Drocourt-Queant Line near Arras, France, on 2 September 1918. His citation reads: 'For most conspicuous bravery, initiative, and devotion to duty when, after an unsuccessful attack, Sergeant Knight led a bombing section forward, under very heavy fire of all descriptions, and engaged the enemy at close quarters. Seeing that his party continued to be held up, he dashed forward alone, bayoneting several of the enemy machine-gunners and trench-mortar crews, and forcing the remainder to retire in confusion. He then brought forward a Lewis gun and directed his fire on the retreating enemy, inflicting many casualties.

In advance of his platoon, Sergeant Knight saw a party of around thirty of the enemy go into a deep tunnel which led off the trench. He dashed forward alone, and, having killed one officer and two NCOs, captured twenty other ranks. Subsequently he routed, single-handed, another enemy party which was opposing the advance of his platoon. On each occasion he displayed the greatest valour under fire at very close range, and by his example of courage, gallantry and initiative was a wonderful inspiration to all.

Knight was killed the following day, struck in the head by shrapnel from an enemy shell and is honoured by a large marble plaque at the Haywards Heath Town Hall, and by a commemorative stone at the town's war memorial on Muster Green.

Among the other seven Canadian recipients awarded the VC was Hastings-born Claude Joseph Patrick Nunney VC, DCM, MM whose citation states: 'On Sept. 1st, when his battalion was in the vicinity of Vis-en-Artois, preparatory to the advance, the enemy laid down a heavy barrage and counter-attacked. Private Nunney, who was at this time at company headquarters, immediately on his own initiative proceeded through the barrage to the company outpost lines, going from post to post and encouraging the men by his own fearless example. The enemy were repulsed, and a critical situation was saved. During the attack on Sept. 2nd, his dash continually placed him in advance of his companions, and his fearless example undoubtedly helped greatly to carry the company forward to its objectives. When his battalion which was preparing to advance, was heavily counter-attacked by the enemy, Private Nunney on his own initiative, went forward through the barrage to the company out-post lines, going from post to post and encouraging the men by his own fearless example.'

Nunney died sixteen days later after receiving a fatal wound in another attack. A memorial paving stone and panel in Alexandra Park, Hastings, commemorate him.

Hastings has another VC recipient. Sir Fenton Aylmer, 13th Baronet, was a captain in the Corps of Royal Engineers, British Army and Bengal Sappers and Miners during the Hunza–Nagar Campaign, India, when he won the Victoria Cross in 1891 for the following

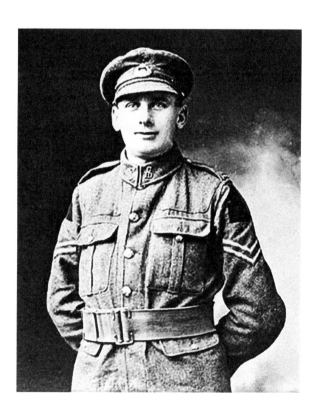

Arthur George Knight VC.

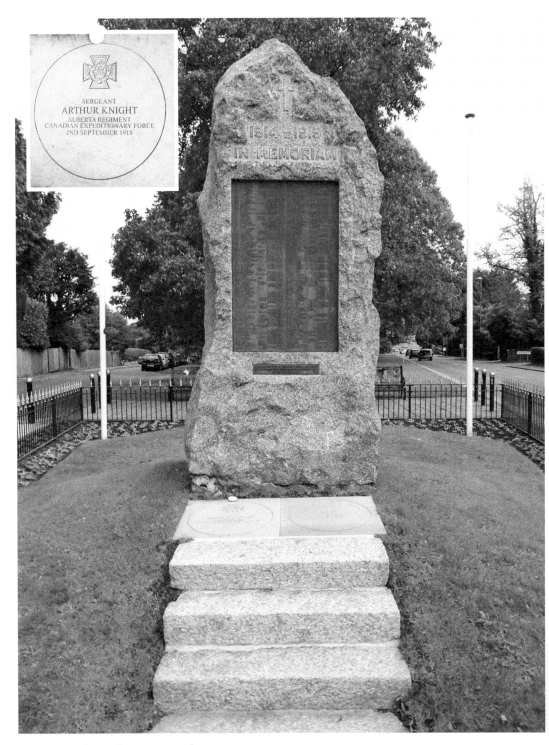

Haywards Heath war memorial.

Inset: stone memorial.

Claude Joseph Patrick Nunney VC.

deed: 'On 2 December 1891 during the assault on Nilt Fort, British India, Captain Aylmer, with the storming party, forced open the inner gate with gun-cotton which he had placed and ignited, and although severely wounded, fired nineteen shots with his revolver, killing several of the enemy, and remained fighting until, fainting from loss of blood, he was carried out of action.'

Another coastal town linked to the VC is Eastbourne, home of Company Sergeant Major Nelson Carter of the Royal Sussex Regiment. Of the regiment's four VC recipients during the First World War, he was the only soldier born in Sussex. A blue plaque can be seen on the wall of his home at No. 33 Greys Road, Eastbourne, and at Eastbourne Pavilion Gardens is a memorial paving stone. He was awarded the VC for his actions on 30 June 1916 at Boar's Head, Richebourg l'Avoue, France, his citation reads:

> For most conspicuous bravery. During an attack he was in command of the fourth wave of the assault. Under intense shell and machine gun fire he penetrated, with a few men, into the enemy's second line and inflicted heavy casualties with bombs. When forced to retire to the enemy's first line, he captured a machine gun and shot the gunner with his revolver. Finally, after carrying several wounded men into safety, he was himself mortally wounded and died in a few minutes. His conduct throughout the day was magnificent.

Eighteen VC recipients are buried in Sussex's cemeteries. St Mary's churchyard, West Chiltington, contains two – Major General Henry Robert Bowreman Foote and

Left: Sir Fenton Aylmer VC.

Below: Monument to Nelson Carter VC.

Captain Geoffrey Harold Woolley – as does Bear Road Cemetery, Brighton, where Captain Frederick Charles Booth and Company Sergeant Major George Gristock are interred. The churchyards and military cemeteries contain several thousand Commonwealth War Graves Commission burials and other important military interments. Though these are often overlooked as sources of military heritage, they offer a wealth of historical and contextual information, often unknown or unrecorded elsewhere.

In the churchyard of St John sub Castro, Lewes, is a Russian memorial to twenty-eight Finnish soldiers of the Imperial Russian Army taken prisoner at the Baltic fortress of Bomarsund during the Crimean War. The obelisk was erected in 1877 at the behest of Tsar Alexander II of Russia as a memorial to the soldiers who died while confined in Lewes Naval Prison.

Russian officers brought to Lewes as prisoners were housed with local families and integrated themselves into society, while their soldiers, Finns, made wooden toys that they sold from the prison and which became a visitor attraction. The local press reported they were 'too well fed' and that 'scarcely a prisoner is without a watch, and many of the timepieces are of gold'. Following the war in 1856, the civic authorities and townspeople, along with a military band, turned out to wave the survivors farewell.

Russian monument, Lewes.

Another interesting Crimean war grave in the churchyard is that of Richard Davis, who took part in the infamous Charge of the Light Brigade, at Balaclava in 1854. Riding with 11th Hussars, he was wounded during the charge and invalided out of the army in 1856. He worked in Lewes Prison as a warder, on the railway as a porter and at the town's infirmary. He died, at the age of seventy, on 27 December 1897 and was thought to have shared a common grave until the discovery of his headstone in 2005.

Many of the military aviation memorials to be found in Sussex exist because of acts of heroism and bad luck. Between 1939 and 1945, many RAF Bomber Command missions flew over Beachy Head en route to Europe. For many of the 55,573 men who died on operations, this was their last view of Britain. Those men are commemorated on the clifftop close to the Peace Path by a 6-ton granite memorial over 6 feet (1.82 metres) high.

The base of the old Lloyds Watch Tower is also along this path; upon its outer wall are two memorial plaques. One is to the memory of the men and women who defended Sussex's coastline during the Second World War, while the other commemorates five French soldiers who, despite the natural and wartime dangers, crossed a 60-mile stretch of the English Channel in canoes from Picardie to Eastbourne to join the British war effort on 16 September 1941.

Further along the cliff at Butts Brow is a memorial to the ten American airmen of the 506 Squadron, 44th Bombardment Group, 8th United States Army Air Force who died when their B-24D Liberator Bomber crashed at that location on 2 February 1944. Their

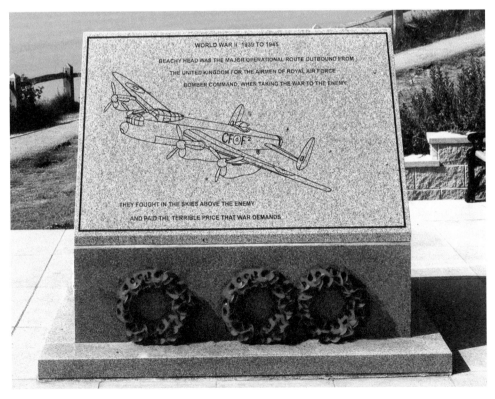

Bomber Command monument.

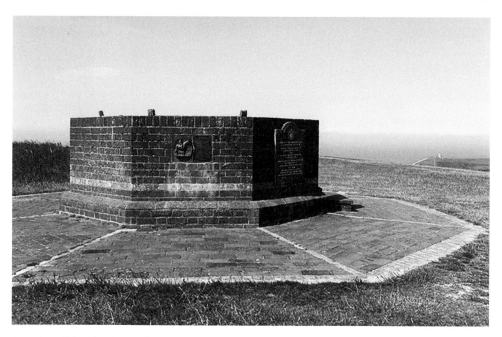

Remains of the Lloyds Watch Tower.

plane *Ruth-Less* was hit by enemy fire over Watten, France, damaging two of its four engines. Leaking fuel and losing altitude, pilot First Lieutenant Bolin realised he would not reach Shipdham, Norfolk, and headed towards the airfield at Friston, Suffolk. The plane, unable to gain altitude, flew along the coastline at rooftop height. People watched as it slammed nose first into the cloud-covered Downs, flipped over onto its back and exploded into a fireball. Eight crew died and two were taken to hospital but later died.

Sussex played an important role in the Battle of Britain (10 July–31 October 1940) and its countryside was scarred with the wrecks of planes from both sides. Fatalities resulted in some poignant memorials being erected. On 18 August 1940, an enemy raider bombed Pontin's Broadreeds Camp, Selsey, then used as a refuge for London evacuees. Among those killed in the attack were three London evacuees, among them a thirteen-year-old boy. A large metal plate on a shingle plinth remembers them.

Among the stories of British heroes of the Battle of Britain is the incredible story of an American, Pilot Officer William Meade Lindsley Fiske III. Billy Fiske, an American citizen, was educated in England and was an accomplished sportsman who led the United States' bobsleigh team to gold medals in 1928 (he was then only sixteen years old) and 1932 Winter Olympic Games. He was invited but declined to lead the team in the 1936 (German) games.

In September 1939 he joined the RAF, pledging his life and loyalty to King George VI. Posted to No. 601 (the Millionaires') Squadron, based at Tangmere, he was scrambled on 16 August 1940 to meet the incoming Stuka raid on the airfield. During the raid he was shot down but managed to force-land his Hurricane on the airfield where he was pulled out from his blazing cockpit. Badly burnt, he died the following day in the West Sussex

Hospital, Chichester, and was buried with full military honours three days later in the churchyard at St Mary and St Blaise, Boxgrove, a mile north of RAF Tangmere.

A little-known hero of the Battle of Britain is the Rector of Stopham and Hardham and Chaplin to the Royal Navy William Masefield, who died gallantly on 4 October 1940 protecting a group of children as a German aircraft machine-gunned them. On seeing the plane coming into attack, Mr Masefield ushered the children into a nearby ditch and in so doing was fatally shot. All the children survived. A memorial by the ditch along the A283 road, south of Stopham bridge, marks the location of his heroism.

At St Mary the Virgin, Upwaltham, is the Four Nations War Memorial in remembrance of the fifteen airmen from Australia, America, Canada and Britain who lost their lives in two separate crashes at Upwaltham almost a year to the day apart. The first involved an Avro Lancaster carrying experienced veterans of 617 Dam Buster Squadron. Returning on 13 February 1944 from a bombing raid against the Antheor Viaduct in Southern France, the squadron made a scheduled stop at the Royal Naval Air Station, Ford. Three hours later, at 5.15 a.m., the crew took off. Low cloud made visibility poor and within five minutes they'd flown into trees at the top of Littleton Down, where the Lancaster broke up and burst into flames, killing all eight crew.

Twelve months later on 11 February, a C-47 Skytrain (Dakota) of the 311 Ferrying Squadron, 27th Air Transport Group, was on a non-operational flight carrying freight and mail from Istres in France to the US Air Force base at Grove, Berkshire. Flying in poor weather between 300 and 400 feet, in zero visibility they began ascending through the cloud passing over RAF Tangmere. At around 12:00 a report was received at Flying Control Tangmere that an aircraft had crashed into a hill north of the airfield. The disintegrated remains of the C-47 were discovered between West Wood and Burton Down. The investigating party concluded the pilot had reduced altitude over the English Channel

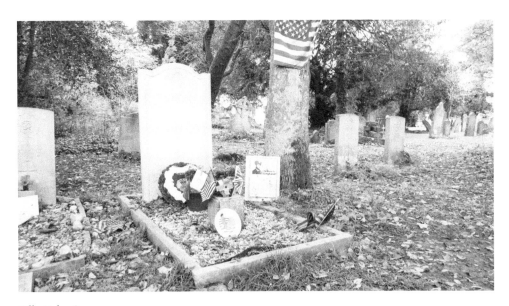

Billy Fiske, Boxgrove.

Above: Memorial to Revd William Masefield, Stopham.

Right: St Mary the Virgin, Upwaltham.

IN REMEMBRANCE OF FIFTEEN
AIRMEN FROM AUSTRALIA, AMERICA, BRITAIN
AND CANADA WHO LOST THEIR LIVES AT
UPWALTHAM WHILE ON ACTIVE SERVICE
DURING THE SECOND WORLD WAR

LANCASTER BOMBER DV382
617 DAMBUSTER SQUADRON
13 FEBRUARY 1944
Après moi le déluge

SUGGITT *William R, Squadron Leader* DFC, RCAF
DAVIDSON *Norman J, Flying Officer* RCAF
GORDON *John I, Pilot Officer* DFC, RAAF
DEMPSTER *John M, Flying Officer* DFM, RCAF
HALL *Sydney G, Flying Officer* RAAF
PULFORD *John, Flight Sergeant* DFM, RAF
RICHES *John P, Flight Sergeant* RAFVR
LLOYD *Thomas W, Squadron Leader* DSO, RAF

DAKOTA C47-B
27th TRANSPORT GROUP
US ARMY AIRFORCE
11 FEBRUARY 1945

POGUE *Richard L, 1st Lieutenant* USAAF
ROBINSON *Robert G, 2nd Lieutenant* USAAF
SMITH *Jerome T, Corporal* USAAF
CORSON *Victor C, Staff Sergeant* USAAF
MOORE *Craig C, 2nd Lieutenant* USAAF
NORRIS *Robert S, Sergeant* USAAF
CLAYTON *Carl, Sergeant* USAAF

Raised by the parishioners of Upwaltham in 2009

but did not break out of cloud and had not realised he was flying over the southern coast of England. Examination of the debris pattern suggested the pilot banked sharply when he saw the hill and collided with trees, tearing the left wing off. The plane cartwheeled killing all three crew and four passengers.

In another crash on 28 May 1941, a Wellington bomber of No. 304 Squadron crewed by Polish airmen crashed near Darwell Hole, Netherfield. Having attacked shipping in Boulogne harbour, the bomber was hit, setting one engine alight. The rear gunner, Jozef Drodz, bailed out and was never seen again. The plane struggled back across the channel and when the second engine began failing, the pilot ordered the crew to bail out, but only sergeants Joseph Nilski and Stanislaw Jozefiak escaped before the plane crashed into a large oak tree and broke up, killing the remaining three crewmen. After the war, Jozefiak lived in Derbyshire, and only returned to Sussex in 2000 when the landowner of the crash site donated land for a memorial. He began building a monument to his crewmates, adding to it on each visit. It was completed on the day of the sixtieth anniversary of the crash.

Sussex has several unusual and unique memorials. On the west side of the Cuckmere Valley is a small cairn erected in 2006 that honours an unknown number of Canadian soldiers allegedly killed during an air raid in 1940 while camped in the field. Official investigations have found no record of the event or the names of the dead soldiers. The memorial was erected following unsubstantiated eyewitness testimony of a local veteran, Leslie Edward, who'd laid poppies there every Remembrance Sunday for sixty years until his death in 2004.

A beech tree at Dallington Forest is a rarely seen but significant military monument known as the 'POW Tree'. Carved into the tree, at a height of 9 feet (3 metres) from the ground is the inscription 'TB KÖLN 1946 P.O.W.' The tree now serves as a monument to the many German prisoners of war camped in Sussex who worked the land during and after the war while waiting to be repatriated.

Another unique memorial sits beneath the ancient tower of Holy Trinity Church, Bosham, and is a memorial to the men of both world wars in the form of a double gravestone. The inscription refers not to the fallen of those wars, but to a poem about the clock in the tower that rings for the passing hours to remind passers-by of their sacrifice.

Along the South Downs Way in Phillis Wood Down near Didling is a mysterious memorial to a German Battle of Britain pilot, Hauptmann Joseph Oestermann, 1915–40. Oestermann died on 13 August when his Junkers JU-88 was attacked by Hurricanes from RAF Tangmere. He kept the damaged plane airborne long enough for his two comrades to bail out before the plane turned into a vertical spin and exploded as it hit the ground. Oestermann's remains were never found and in 1988, a British Aviation Association unveiled a memorial stone to him, which is regularly visited and tended by unknown persons.

Towards the end of the war, Hitler deployed his vengeance weapon, the V-1 flying bomb, against Britain with devastating and indiscriminate effect. It cruised above the effective range of light anti-aircraft guns, but below the range of heavier guns, making it difficult to bring down. Barrage balloons were deployed but were ineffective at stopping the bombs landing in built-up areas. To save lives, fighter pilots used their skills to neutralise

Above left: POW Tree, Dallington.

Above right: Hauptmann Joseph Oestermann. (ARS)

Right: Monument to Hauptmann Joseph Oestermann, Didling.

the bombs in flight. Shooting down a V-1 with its 1-ton payload at 350 mph (563 kph) was dangerous, and many pilots were killed flying into the resulting fireball of flying metal.

Such a fate befell twenty-three-year-old Flying Officer George Mercer McKinlay of the Royal Air Force Volunteer Reserve (RAFVR), serving with 610 Squadron. Having previously downed two V-1 rockets on 12 July 1944, he spotted another over the harbour approaching the town of Newhaven. Intercepting the V-1, he fired on it and was in pursuit when it detonated, creating a tremendous fireball. Eyewitnesses watched his crippled burning Spitfire emerge from the explosion and head towards the town. George could have bailed out but guided his plane to safety. Before he could escape, his plane stalled and crashed into the fields nearby. His bravery is commemorated at New Haven Fort with a commemorative plaque.

Such incidents led to pilots learning to fly with the wingtip of their plane just below that of the V-1. The disrupted airflow would cause it to topple the gyros and divert them off course. This was a perilous practice as Belgium-born Flight Lieutenant Eugene Seghers discovered. A veteran of the Battle of Britain, who at the time of the incident was serving with 91 Squadron HQ, Seghers was on patrol on 26 July 1944 when he spotted a German V-1 flying bomb south of Uckfield. The V-1's engine cut out and it began diving towards the town centre. Using his plane, he attempted to deflect the V-1 away from Uckfield using his own aircraft's wing. In attempting the manoeuvre, he misjudged his distance and struck the missile, causing it to explode, killing him outright. His action saved the lives of hundreds of Uckfield residents, and in the grounds of The Highlands Inn, Uckfield, is a rectangular Belgian Blue Stone tablet set into a purpose-built arch-topped brick wall that memorialises him and his sacrifice.

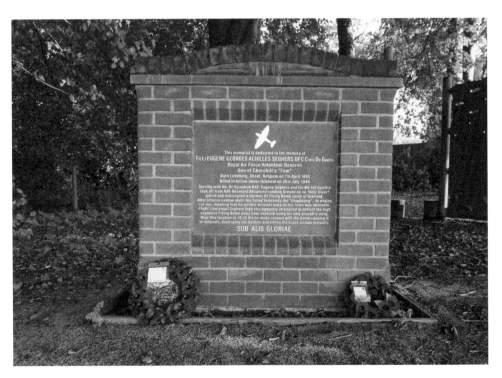

Monument to Eugene Seghers.

7. Military Formations of Sussex

Since time immemorial, the men of Sussex have defended their communities, but it wasn't until the formation of the Anglo-Saxon militia that men were trained in the art of soldiering. Even then, centuries passed before the part-time militia gave way to Cromwell's 1645 New Model Army blueprint for a national army of full-time professionals.

Militia continued to be formed in Sussex, as and when invasion fears from France heightened. Voluntary enlistment brought extra troops, including cavalry and infantry into Cinque Port Volunteer Militia Corps. In 1803, a militia of seafarers known as the 'Sea Fencibles' was raised to man watchtowers, signal towers and coastal batteries from Selsey Bill to Beachy Head. Disbanded in 1816, various companies of the Cinque Ports Volunteers formed themselves into rifle clubs.

In January 1858 a bomber attempted to assassinate Napoleon III, the French head of state. Enquiries revealed the bomb had been made in England, a fact that created a public outcry in France calling for a French invasion of Britain. This threat brought the formation of the Cinque Ports Rifle Volunteers (CPRV) and Local Rifle Volunteer Corps (LRVC) being established in principal ports and towns across the country under the command of the county's Lord Lieutenant.

These part-time soldiers trained for a minimum of twenty-four days a year, in musketry, drill and other military procedures, to become an effective fighting force. While there had been a civilian army prior to this, created from various militia, yeomanry

theorangelily.jimdo.com.

and the Napoleonic era volunteers, the CPRV and LRVC were formed as an autonomous organisation, grouped by county who recruited middle-class working men who could afford the entry subscription. Members also had to purchase their own weapons and uniforms and as a result subject to the lord-lieutenant's approval were allowed to choose the uniform's design. To differentiate themselves from the scarlet of the army and militia, many CPRV chose green or grey rifleman-style uniforms. The first uniform worn by the Sussex CPRV was grey with red facings and black braiding.

One condition of all volunteer corps gaining official recognition was the need for a range so they could practise shooting. The South Downs holds a number of disused rifle ranges, although most of the original ones no longer exist. At Steyning, volunteers have begun restoration on a range west of Mouse Lane, which was once used by the 18th (Steyning) Rifle Volunteer Corps. In addition to butts, stop butts, a markers gallery, target store, latrines, a workshop and other twentieth-century buildings, there are eight metal target frames, measuring 6.5 feet (2 metres) in length and 8.5 feet (2.6 metres) in height, designed to raise and lower targets from below ground level. The range once had eight firing points located every 100 yards from the stop where the targets were raised. It finally closed in 1989 after failing to meet safety standards, ending 129 years of near constant use.

In 1860 the CPRV consisted of eight companies. No. 1 was at Hastings, with companies 2 to 8 located in Kent. The CPRV and LRVC movements were only one measure put in

Target frames. (Steyning Download Scheme)

place to oppose invasion, or suppress rebellion following the appearance of the enemy. Another was the Volunteer Battalions, who, by 1862, numbered 162,681 nationally. In time these battalions would see active service alongside regular soldiers during the Boer and two world wars.

The Sussex Yeomanry Regiment was a voluntary cavalry unit formed in 1794. However, it declined in importance and strength after the end of the French wars, and in 1828 was disbanded. It was reformed during the Second Boer War, serving in the First World War and the Second World War, when it served in the East African Campaign and the Siege of Tobruk. Today, 1 (Sussex Yeomanry) Field Troop, 579 Field Squadron (EOD) exist as part of 101 (London) Engineer Regiment (Explosive Ordnance Disposal) (Volunteers).

The most recent full-time military representatives of the county were the Royal Sussex Regiment (1881–1966), whose official motto is *Honi soit qui mal y pense* (Shame be to him who thinks evil of it) and unofficial motto 'Nothing succeeds like Sussex'. They were originally raised in Belfast in 1701 by Arthur Chichester, 3rd Earl of Donegall, and were known as 'The Belfast Regiment'. The regimental colours, orange background and facings of the officers' and men's uniforms, were authorised by King William III. In 1782, King George III added county titles to infantry regiments to help local recruitment and the 25th Regiment stationed in Sussex became 'The Sussex Regiment'. While the 35th became the Dorsetshire Regiment, its connection with Dorset is not known. The first connection with Sussex for the 35th came in 1787 when Charles Lennox, 4th Duke of Richmond,

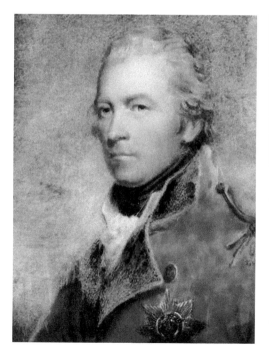

Above left: Charles Lennox, 4th Duke of Richmond.

Above right: 35th Regiment of Foot, Royal Sussex Society.

who had family estates in Sussex, joined the regiment. In 1801, the 25th's recruiting area was moved to the Scottish Borders and in 1804, Lennox obtained royal permission for the title 'Sussex' to be transferred from the 25th to the 35th, the 25th becoming (the King's Own Borderers) Regiment of Foot.

King William IV added the title 'Royal' in 1832 and changed the background of the regimental colours and uniform facings to blue, signifying a 'Royal' regiment. Throughout its history, the Royal Sussex Regiment has served with distinction and following their defeat of the French Royal Roussillon Regiment at the Battle of Quebec, Canada, in 1759 they were granted authority to wear the white plume of their beaten enemy on their headdress. They bore the white plume for forty years before it was incorporated into their cap badge, which was worn until 1966. The 35th also took the regiment's colours, which bore the French lilies of gold, which is the origin of their nickname the 'Orange Lilies'.

The regiment helped to quell the Indian Mutiny in the 1850s and took part in the 1885 Nile Expedition, seeing action at Abu Klea and El Gubat and during the relief of General Gordon at Khartoum. In 1861, the 107th Regiment of Infantry, the 'Fighting Tigers', merged with the 35th Regiment to form the 1st and 2nd Battalions of the Royal Sussex Regiment. In the 1880s they saw service in Egypt and from 1900 to 1902 in South Africa.

During the First World War, the 1st Battalion were stationed in India. The 2nd Battalion's defence of Marne, France, in 1914 was so staunch the Germans nicknamed them the 'Iron Regiment'. During the war, the Royal Sussex Regiment was expanded to twenty-three battalions and fought at Gallipoli, Egypt, Palestine, Italy and the Western Front.

Cap Badge 1881. (theorangelily. jimdo.com)

Above: 35th Regiment of Foot, Royal
Sussex Society, Second Boer War
re-enactment.

Right: 35th (Royal Sussex) Regiment
of Foot.

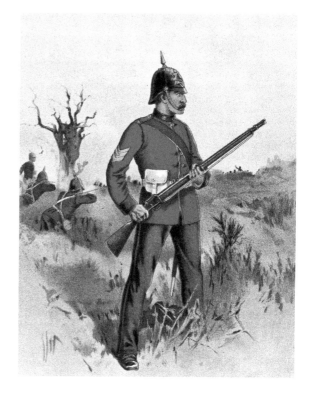

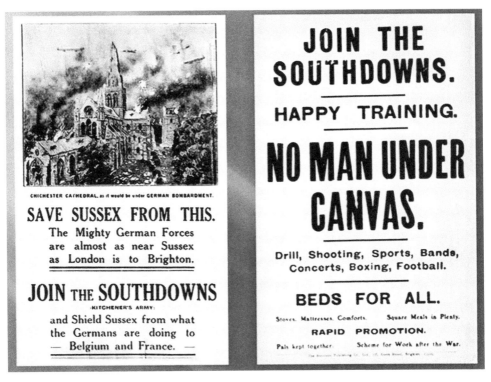

CHICHESTER CATHEDRAL, as it would be under GERMAN BOMBARDMENT.

SAVE SUSSEX FROM THIS.
The Mighty German Forces are almost as near Sussex as London is to Brighton.

JOIN THE SOUTHDOWNS
KITCHENER'S ARMY
and Shield Sussex from what the Germans are doing to — Belgium and France. —

JOIN THE SOUTHDOWNS.
HAPPY TRAINING.
NO MAN UNDER CANVAS.
Drill, Shooting, Sports, Bands, Concerts, Boxing, Football.

BEDS FOR ALL.
Stoves. Mattresses. Comforts. Square Meals in Plenty.
RAPID PROMOTION.
Pals kept together. Scheme for Work after the War.

theorangelily.jimdo.com

Of note are the 11th, 12th and 13th 'Pals Battalions' raised by Colonel Lowther. Known as the 'Southdown Battalions', they became known as 'Lowther's Lambs' due to the heavy losses they suffered at the battle for Ferme du Bois near Richebourg. This was a diversionary attack on the Boar's Head salient, the day before the main infantry attack on the Somme.

At 03:05 on 30 June 1916, the Southdowns went over the top. The Germans knew they were coming and the artillery bombardment at Richebourg had had little effect on their defences. Intelligence had not spotted a large dyke in the middle of no man's land. As a result, the attack was a disaster, and the men were mowed down and unwittingly trapped in the dyke.

When the Southdowns reached the German trenches, brutal and bloody hand-to-hand fighting broke out until the Germans forced them back. The Battle at Boar's Head lasted less than five hours, during which the Southdowns Brigade lost seventeen officers and 349 other ranks. Seventy percent of those who had died were Sussex residents including twelve sets of brothers. Over 1,000 men were wounded or taken prisoner, and the 13th Battalion was all but wiped out. Such was the ferocious nature of fighting, 30 June 1916 was dubbed 'The Day Sussex Died'. As a result of the bravery shown that day, the men of the Southdowns were awarded one Victoria Cross, twenty Military Medals, eight Distinguished Conduct Medals, four Military Crosses and one Distinguished Service Order. During the war the regiment lost 7,096 men and was awarded sixty-nine battle honours.

In the Second World War, the 1st Battalion fought in Abyssinia in 1940–41, Libya in 1941–42, Tunisia in 1942–43 and Italy and Greece in 1944. The 2nd Battalion fought in France in 1940 and suffered heavy casualties during its retreat to Dunkirk. They returned to action in North Africa in 1942. In 1943, the 2nd Battalion, along with volunteers from the Territorial 4th and 5th Battalions, was converted into 10th Battalion, The Parachute Regiment, and saw action in Holland (Operation Market Garden.) Meanwhile, a new 2nd Battalion was formed to fight in the invasion of Persia (now Iran) and Iraq in 1943. Altogether, fourteen battalions were raised during the war. Most were used for home defence and for training units. The Territorial 6th and 7th fought in France in 1940, and the 9th in Burma in 1943–45.

The Royal Sussex's Regiment's only VC of the war came in fighting at Arnhem, Holland, to Captain Queripel, 10th Battalion, The Parachute Regiment. His citation states: 'During nine hours of confused and bitter fighting displayed the highest standard of gallantry under the most difficult and trying circumstances. His courage, leadership and devotion to duty were magnificent, and an inspiration to all.' Captain Queripel was captured and died from wounds inflicted while covering the withdrawal of his men.

Re-enactor, private 10th Parachute Battalion (Royal Sussex Society).

In 1966, the Royal Sussex Regiment merged with The Queen's Royal Surrey Regiment, The Queen's Own Buffs, The Royal Kent Regiment and The Middlesex Regiment (Duke of Cambridge's Own) to form The Queen's Regiment.

Today re-enactors of the 35th Regiment of Foot, Grenadier Company of the Royal Sussex Regimental Society through battle re-enactments and living history displays promote the experience of the British soldier, keeping alive the memory of the regiment and the times in which it served. The society, located in New York City, focusses on the eighteenth-century history of the regiment, the American Revolutionary War (1775–83) and the War of the Spanish Succession (1702–14), although the society also keeps alive other, later chapters of the regiment's history.

Similarly, the 23rd Sussex Home Guard are a re-enactment group from the south of England who take part in full-scale living history displays, show and tell events and practical lectures covering almost every aspect of the Home Guard during the Second World War. The Sussex Home Guard was formed on 14 May 1940, and by 1944 twenty-six battalions had been raised across the county. Initially known as 'Local Defence Volunteers', the named changed on 31 July 1940. In the early days, uniforms and equipment were scarce, so emergency measures were taken. Uniform often consisted of just an armband with 'LDV' or 'Home Guard' written on it, a steel helmet and military gas mask. Battledress uniforms and military equipment were provided when they became available with obsolete military rifles gradually replacing shotguns, pitchforks and official issue 'pikes' (a long bayonet welded onto the end of a steel pipe). It is through such groups the proud name, traditions and customs of the historic military men of Sussex lives on.

8. Museums and Militaria

One of the greatest sources of information about military heritage and militaria are museums, particularly museums within former and existing military establishments, buildings or other sites of historical importance. Such venues act as hubs of cultural importance where history and heritage combine to tell and show stories of historical significance through their collections, exhibits, archives, exhibitions and artefacts, all held in trust for future generations.

Among the locations, military installations and fortifications that survive as visitor attractions and museums, Battle Abbey houses a multimedia educational visitor centre with exhibitions, a cinema and interactive displays that tell the story of the now famous Battle of Hastings and events surrounding it.

The site of the battlefield survives as was and with the ruins of the abbey close by, it remains an important heritage site which can be explored with or without the aid of an audio guide. Carved wooden sculptures of soldiers and horses adorn the battlefield, and re-enactors within the grounds bring the venue to life. However, it's the annual re-enactment of the Battle of Hastings itself on the weekend nearest 14 October that takes visitors back in time.

Carved Norman figure, Battle.

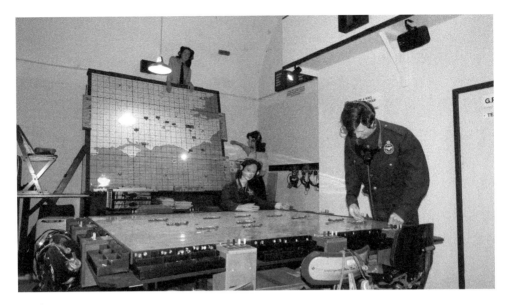

Newhaven Museum.

Newhaven Fort, built in the nineteenth century to defend the harbour, is the largest defence work ever built in Sussex. Now open as a museum, its shared visitor experiences, interactive galleries and exhibitions tell the story of the fort's life from its roots as an Iron Age fortress to Victorian fort, and the lives of the soldiers and their families who have lived and worked there from the Victorian period to modern day.

Among its many galleries the 'Lost Fort' provides an immersive experience that explores Newhaven's pre-Roman military links, and how fear of invasion created the Iron Age fortress upon which the present fort is built. The story of how Newhaven became a base for torpedo boats, minesweepers, and seaplanes during both world wars, and how its connected to the disastrous Dieppe raid of 1942 and the successful D-Day landings of 1944 are told within the 'Sussex Sea and Air' exhibition. The 'Home Front' gallery and 'Air Raid' experience show how the Second World War impacted upon everyday life in Sussex and how during the Battle of Britain, the skies over Sussex were scarred by dogfights and darkened by low-level surprise attacks and bombing raids. Also on display at the museum is a collection of militaria associated with the Sussex Yeomanry.

At Rye Castle the museum reveals the social and military history of Rye through artefacts, photographs, costumes and historic documents. Included among its military exhibits and militaria collections are weapons and uniforms used by local units through the ages. The Ypres Tower that once protected Rye from attack now houses the 'Rye Tower Embroidery', which tells the tower's turbulent 600-year history.

The Georgian Redoubt Fortress in Eastbourne is one of Sussex's most historic landmarks and is now a military museum that tells the fort's 200-year history culminating in its roles during both world wars and its use by the Military Police, Home Guard and Canadian forces. The large circular fort was built in 1805 as part of Britain's anti-invasion preparations during the Napoleonic War and offers visitors free guided tours at weekends,

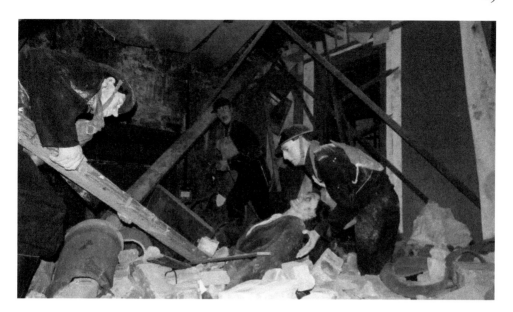

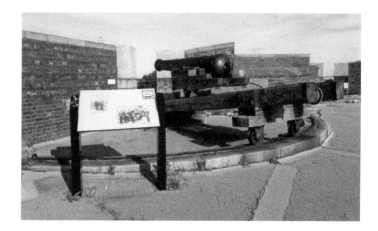

Above: Newhaven Museum.

Right: The Redoubt Fortress and Military Museum.

during which tales and secrets of residents long since gone are revealed. Throughout the year it hosts a programme of military heritage events within the fort with re-enactments and demonstrations of military life and activities.

The Royal Sussex Regimental Museum and its collection of VC medals was co-located within the museum. However, following extensive renovations at the fortress, the museum's inventory was removed and placed into storage awaiting reallocation to new premises.

A more unusual museum is housed within Martello Tower No. 74, the Seaford Museum and Heritage Society. Nicknamed the Tardis by visitors, it maximises its 5,000-square foot display area with galleries on the roof, entrance floor, lower tower floor and covered dry moat area. The museum displays exhibits from the town's days as an important military and commercial Cinque Port to Seaford's role during both world wars. Included among the wartime militaria and memorabilia are a replica wartime kitchen and a converted

air-raid shelter showing a film about Seaford during the Second World War. Throughout the year the museum hosts a variety of talks and heritage open days and is run and supported by volunteers.

The Henfield museum is the smallest military museum and is run by the parish council. The museum details its association with the Sussex Rifle Volunteers Regiment with a section of the museum dedicated to their weapons and uniforms, many of which once belonged to prominent Henfield residents.

RAF Tangmere near Chichester became operational in 1918 and at the start of the Second World War became a stepping-off point for squadrons moving to France to support the British Expeditionary Force. It served as a fighter base playing a vital role in the Battle of Britain and was in the front line throughout the fight. The German Luftwaffe conducted a major attack on the airfield on 16 August 1940, which lasted twenty minutes but destroyed many of the airfield buildings. Despite this the station remained operational throughout the day and throughout the rest of the battle. In August 1942 the Tangmere supported the 1942 Canadian raid on the port of Dieppe and in 1944, with its associated airfields, was important in supporting the D-Day landings. During the war many notable pilots flew from Tangmere including Douglas Bader, Billy Fiske, Caesar Hull, Desmond Scott and Hugh Verity.

In 1958 Fighter Command left RAF Tangmere and in October 1970 the airfield closed. In June 1982 the Tangmere Military Aviation Museum opened with its unique collection of military aviation memorabilia from the First World War to the Cold War. Since that time it has been staffed entirely by volunteers.

Located among the galleries are fixed-wing aircraft, helicopters and aircraft engines. Exhibits include historic fighter aircraft, full-size replicas of the Spitfire prototype K5054, a Hurricane Mk 1 and a Special Duties Lysander, flight simulators and many interactive displays. The museum's 'Air Raid Experience', complete with realistic sound effects,

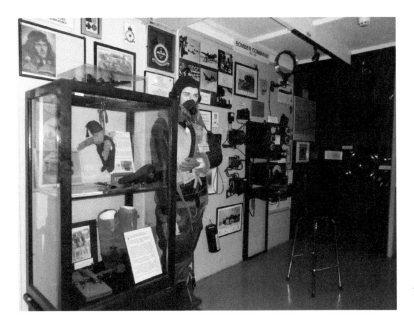

Tangmere Museum.

uses part of an original Second World War air-raid shelter and provides visitors with an opportunity to experience the 1940 Luftwaffe raid on the airfield.

Five aircraft are displayed on the edge of a large car park and other aircraft are displayed inside aircraft halls. The Meryl Hansed Memorial Hall houses a Hunter F5 and a Lightning F53; the Merston Hall accommodates three aircraft owned by the RAF Museum, a Swift FR5 and two world airspeed record holders; the RAF High Speed Flight's Meteor flown by Group Captain 'Teddy' Donaldson in 1946; and the Hawker Hunter prototype flown in 1953 by Squadron Leader Neville Duke (a past president of the museum). The three display halls hold many of the museum's smaller artefacts including equipment used by SOE agents who were flown out of Tangmere at night by pilots of No. 161 Special Duties Squadron in Lysanders and Hudsons to French farmers' fields. Among their number was James 'Mac' McCairns, who flew with Bader's Tangmere Wing in 1941 until he was shot down and captured by the Germans. He escaped from a German prisoner-of-war camp in 1942 and after reaching Brussels was assisted by the Belgian/French Comet Resistance line who smuggled him back to England via Gibraltar. He became a Lysander pick-up pilot and in twelve months achieved twenty-five successful missions and was awarded three Distinguished Flying Crosses.

The museum relates its stories through the people who flew from and worked at RAF Tangmere and its associated airfields. It has some unique artefacts including the tunic worn by James Nicolson VC, the only Fighter Command pilot to receive this medal in the Second World War, and the remains of a Hurricane (P3179) shot down during the Battle of Britain when

James McCairns. (TMAM/McCairns Collection)

Tangmere Museum.

flown by Sergeant Dennis Noble of No. 43 Squadron. The museum features women including those who served in the RAF and the female pilots who flew in the Air Transport Auxiliary.

The Wings Museum near Balcombe is a heritage hub housed within a 12,000-square foot hangar, and like Tangmere its operated entirely by volunteers. Among its artefacts the museum displays rescued and conserved items of military heritage gathered from around the world, Britain and Sussex. Also presented is a nostalgic examination of key military aviation events that have impacted Britain's history. The museum's galleries and information boards display items of militaria, as well as images and information that show the courage, determination, innovation, ingenuity and tragedies experienced by residents and military personnel living and stationed in Sussex during the Second World War.

The museum's volunteer curators – Brian, Daniel and Kevin Hunt – are directly connected to one such tragedy: the bombing of Petworth Boys' School in 1942, in which their relative George Charles Hunt was killed, aged ten. Within the galleries is a poignant display related to this tragedy in which artefacts and personal accounts tell in detail the true horror of the attack.

The galleries are themed: The Home Front, RAF Fighter Command, the Blitz, the Battle of Britain, Bomb Disposal, the Home Guard, air-raid shelters, aircraft turrets, RAF Bomber Command, the US 8th Air Force, the Luftwaffe, the Russian Front and D-Day. They include engines, airframes, cockpits, gun turrets, uniforms, medals, flying equipment and hundreds of personal accounts of sacrifice and courage during the war years. At the centre of the museum is a complete fuselage from a Douglas C-47 Skytrain, which visitors can walk inside. This was used during the filming of the TV hit series *Band of Brothers*.

93

Wings Museum.

Charles Hunt and his sister. (DH)

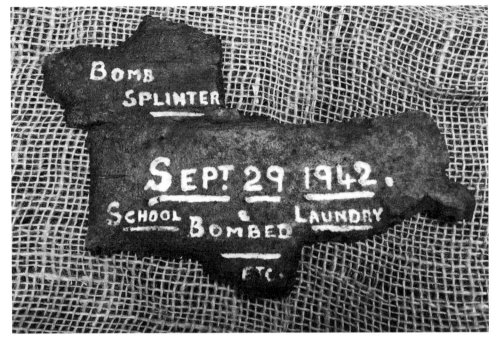

Shrapnel splinter, Petworth Boys' School. (DH)

Wings Museum.

Acknowledgements

In finding the primary sources needed to research and produce this publication I am thankful and indebted to the many wonderful and like-minded people who I have met along the way. Their help, guidance, generosity and support have proved invaluable.

I am thankful to: Colin Anderson of the Pillbox Study Group; Alastair Lawson from the Airship Heritage Trust; the East and West Sussex County Council library services; the staff at the East and West Sussex records offices; Abigail Hartley, County Archivist, and Katherine Buckland, Heritage Engagement Officer, Lewes District Council and Eastbourne Borough Council; and Justin Russell of the Sussex Military History Society.

Ian Mulcahy/http://iansapps.co.uk 2019; Doug Edworthy, Tree Champion Brightling and Dallington; Leslie Deacon, https://theorangelily.jimdo.com; Ed Combes and Mark Russell (Cuckfield Nuclear Bunker), Edcombes/www.thetimechamber.co.uk2019/ ww.facebook.com/cuckfieldnuclearbunker; Phillipa Malins at the Cuckfield Village Museum; Cuckfield Parish Council; David King, Melvin R. Brownless and Alexander D. King at the Aircrew Remembrance Society; Daniel Hunt and staff of Wings Museum; David Coxon, Pete Pitman and staff of Tangmere Museum; Philip Baldock and Kath Dudley at Newhaven Fort Museum; the Steyning Downland Scheme; John Van Vliet, president of the Royal Sussex Society; and members of the Rushmoor Writers Group, without whom it would not have been possible to complete this project.

For allowing the use of their images I am obliged to: Airship Heritage Trust (AHT), American Library (AL), Colin Anderson (CA), Doug Edworthy (DE), Dreamstime (DT), Ed Combes (EC), Ian Mulcahy (IM), Justin Russell (JR), Leslie Deacon, (LD), Lewes District Council and Eastbourne Borough Council (LDC&EBC), Martyn Pattison (MP), Mike Searle (MS), Oast House Archives (OHA), Roger Thomas (RT), Simon Burchell (SB), Welcome Images (WI), West Sussex Record Office (WSRO), Tangmere Military Aviation Museum (TMAM), Wings Museum (WM), Aircrew Remembrance Society (ARM), and David King, Melvin R. Brownless and Alexander D. King. All other images are from the author's collection or free from copyright.

To Sharon Berry, Jane Sleight, and Cathrine Milne, three talented and engaging proofreaders, and to Shelly Dodd for producing the original artwork. I offer a special thanks for their continued meritorious support of me. Thanks too to my wife Maria Hollands, for keeping me focussed and allowing me the time to write. I am also grateful to Amberley Publishing for their continued support and for making my ambitions a reality.

About the Author

From a young age Dean was interested in military history. Following his father, grandfather and great-grandfather, he joined the army at sixteen, serving with the Royal Army Ordnance Corps for eight years as a Supply Specialist and Physical Training Instructor in the UK, West Germany, and the Falkland Islands, attaining the rank of Corporal. Following this he joined Surrey Police, retiring as a Detective Chief Inspector after twenty-six years' service.

Today Dean conducts battlefield tours in the UK and Europe and is a member of the Battlefield Trust, Guild of Battlefield Guides, and the Western Front Association. When not guiding he undertakes local history walks and talks, covering a variety of military subjects. He is also a volunteer at the Aldershot Military Museum and acts as a guide for the Commonwealth War Graves Commission at Brookwood Military Cemetery, and for the Brookwood Cemetery Society.

Dean presents lectures at colleges and universities and has been invited to speak at national and international conferences about military history and acts as a consultant for the planning and delivery of the New Jersey State Association of Chiefs of Police's (NJSACOP) annual European battlefield staff ride programme.